Painting **Landscapes** *In Oil*

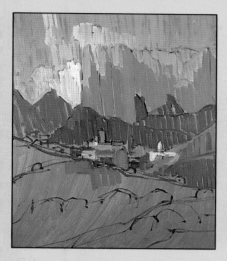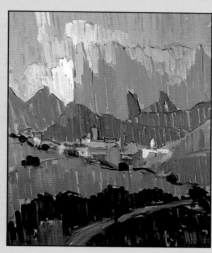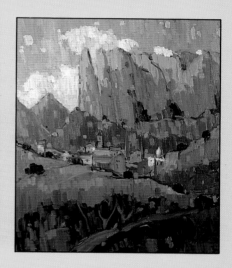

JOSE M. PARRAMON

Watson-Guptill Publications/New York

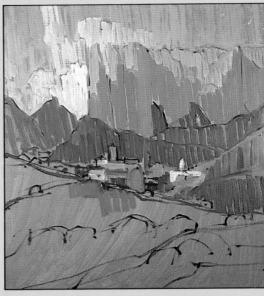

Copyright © 1988 by Parramón Ediciones, S.A.

First published in 1990 in the United States by Watson-Guptill
Publications, a division of BPI Communications, Inc.,
1515 Broadway, New York, New York 10036.

Library of Congress Cataloging-in-Publication Data

Parramón, José María.
 [Pintando paisaje al óleo. English]
 Painting landscapes in oil / José M. Parramón.
 p. cm.—(Watson-Guptill painting library)
 Translation of: Pintando paisaje al óleo.
 ISBN: 0-8230-2597-7 (paperback)
 1. Landscape painting—Technique. I. Title. II. Series.
 ND1342. P3313 1990
 751.45'436—dc20 90-12551
 CIP

Distributed in the United Kingdom by Phaidon Press Ltd.,
Musterlin House, Jordan Hill Road, Oxford OX2 8DP.

Manufactured in Spain
Legal Deposit: B-21.565-90

1 2 3 4 5 6 7 8 9 / 94 93 92 91 90

Painting **Landscapes** *In Oil*

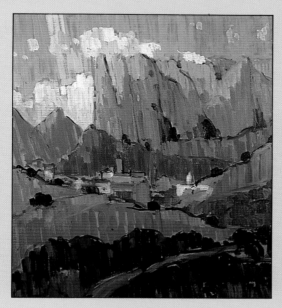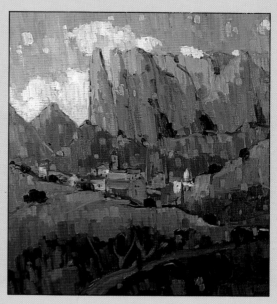

The Watson-Guptill Painting Library is a collection of books aimed at guiding the painting and drawing student through the works of several professional artists. Each book demonstrates the various techniques, materials, and procedures used to paint in specific mediums, such as watercolor, acrylic, pastel, colored pencil, oil, and so on. Each book also focuses on a specific theme: landscape, nature, still life, figure, portrait, seascape, and so on. There is an explanatory introduction in each book in the series followed by lessons in drawing or painting the specific subject matter. In the introduction of this book, you will start by looking at the basic rules of composition and several ways to achieve variety within unity.

Perhaps the most extraordinary aspect of this book is the way in which the lessons (the choice of subject matter; the composition; the color interpretation and harmony; the effects of light and shade; and the technical knowledge and experience along with the secrets and tricks provided by several professional artists) are explained and illustrated line by line, brushstroke by brushstroke, step by step, with dozens of photographs taken while the artists were creating their paintings.

I personally directed this series with a team that I am proud of, and I honestly believe this series can really teach you how to paint.

José M. Parramón

Plato's basic rule for composing a painting

John Ruskin, the English art critic and draftsman, wrote in 1837: "There are no rules about the art of composition. If it were possible to compose through rules, the Titians and the Veroneses would be vulgar men indeed." Despite this seemingly definitive statement, in the following pages we are going to attempt to sum up the general rules on composition in art —and, more specifically, the art of composing in landscape painting.

We must first ask ourselves: What is composition? What should the artist do in order to compose a picture?

Henri Matisse, who along with Picasso was a founder of modern art, once said, "Composition is the art of laying out the different elements the artist has at hand, in a decorative way to express his feelings."

Claude Monet, one of the great impressionist landscape artists, said at the end of the last century: "The artist must bring about a voluntary and sensitive interpretation of nature in his picture."

And that well-known French pedagogue Jean Guitton wrote in his work *The Intellectual Labor*, "Composing is about finding an equilibrium, a proportion, and therefore beauty."

But these thoughts, though valid as an introduction to the subject, do not explain the reasoning, rules, or norms that the artist must follow to compose his picture.

In the fifth century B.C., the famous Greek philosopher Plato answered all questions concerning the art of composition with one statement:

To compose is to seek and represent variety within unity.

A good composition contains variety in the color, variety in the form, and variety in the size and situation of the components.

When this variety exists, the viewer feels attracted to the painting. That variety claims his attention.

But variety should not disconcert or disperse the attention and interest initially created. Therefore variety must respond to the unity of the whole.

Plato made it clear that these two basic factors had to be combined, in such a way as to give the picture:

UNITY within variety;
VARIETY within unity.

Let's see what an artist can do in order to develop and apply these factors to a picture's composition.

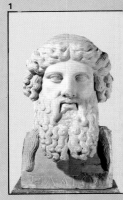

Fig. 1. Bust of the Greek philosopher Plato (428-427 to 348 B.C.). Disciple of Socrates and teacher of Aristotle, Plato formulated a basic norm for composition.

Fig. 2. In the landscape reproduced at the bottom of these pages, countless frames are possible. But in order to achieve unity and variety in the painting, the artist has many other resources at his disposal. In the following pages, we will discuss several of these.

To achieve **UNITY** in their paintings, artists rely on:	To achieve **VARIETY** in their paintings, artists rely on:

a) The organization of form and space, conditioned by the laws of proportion.

b) Symmetry, asymmetry, and form.

c) Traditional and modern geometric compositional structures.

a) Repeated patterns of similar forms.

b) Contrasts of tone, color, and texture.

c) Framing the subject in unusual ways.

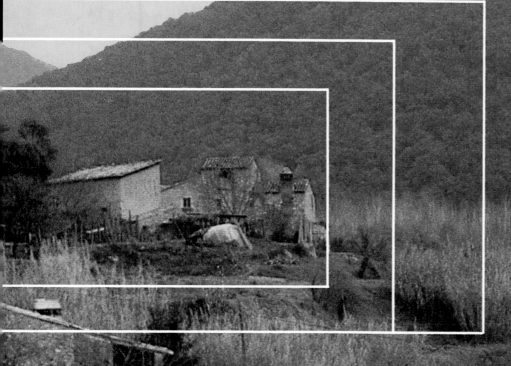

The golden mean: A way to create unity

Let us go back to ancient Greece, this time to the third century B.C., about two hundred years after Plato. At that time, the celebrated mathematician Euclid was living in Alexandria. He was known above all for his masterpiece, *Elements*, an exceptional work on geometry in thirteen volumes. In the sixth book of this work, Euclid studied the aesthetics of proportions and established the ideal division of a line according to its arithmetic mean. He said that a line divided into unequal parts is most aesthetically pleasing if the ratio of the smaller part to the larger part is the same as the ratio of the larger part to the whole.

It took more than fifteen centuries before the famous Italian artist Piero della Francesca and his friend Luca Pacioli, the most celebrated mathematician of the Renaissance, were to rediscover Euclid's formula. Pacioli then wrote the book *Divina Proportione*, illustrated by his closest friend, Leonardo da Vinci. Euclid's formula become known as the rule of the golden mean (or golden number).

As you can see in the box below, the rule of the golden mean solves the problem of where to put the focal point in a painting.

Many artists today deliberately follow this guideline whenever it improves the composition of a painting, just as artists have done in the past. Many other artists, on the other hand, situate a painting, focal point according to the golden mean *without* having previously calculated it, simply through intuition.

This rule is worth taking into account when structuring a landscape.

Figs. 9 to 11. In the three photographs reproduced below, three different frames are shown of the same scene. In figures 9 and 10, the main motif does not stand out sufficiently. The centered subject in figure 9 creates too much unity, while in figure 10 the subject is too far to the right, creating too much variety. But figure 11 illustrates the practical application of the golden mean to situate the main focal point of the painting. The aesthetic guideline discovered by Euclid in ancient Greece is still a valid way to achieve balance in a composition.

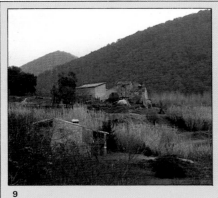

9

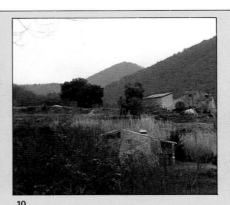

10

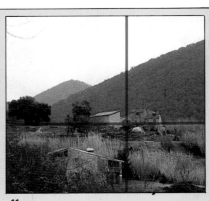

11

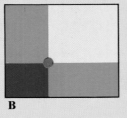

A

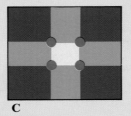

B

C

The rule of the golden mean

Here is a useful composition guideline to take into account when composing a painting: the rule of the golden mean determined by Euclid the Greek mathematician.

A space divided into unequal parts is most aesthetically pleasing if the ratio of the smaller part to the larger part is the same as the ratio of the larger part to the whole.

To find the golden mean within a composition, begin by multiplying the width of your canvas by 0.618. Draw an imaginary vertical line that far across the picture (not quite two-thirds); see diagram A. Repeat this process with the height, drawing an imaginary horizontal line 0.618 of the way up or down your canvas. The ideal location for your focal point is at the intersection of these imaginary lines, as shown in diagram B.

Note in diagram C that there are actually *four* possible locations for the focal point, depending whether you measured from the top or the bottom, or from the right or left. It doesn't matter which of these you use; all four are still determined by the golden mean.

Unity: Symmetry, asymmetry, form

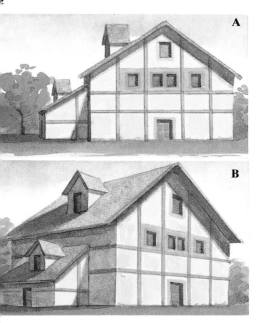

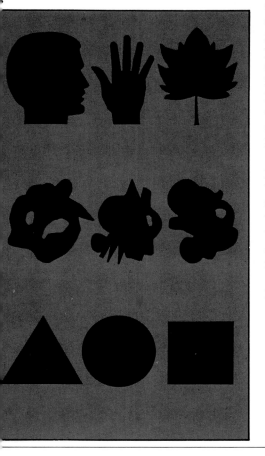

Symmetry creates unity; asymmetry creates variety. We must achieve unity within variety, while taking into account that excessive unity could detract from the composition. Flat even ground without a rough surface, or a village or house facing us symmetrically, looks monotonous and uninteresting to the viewer of the painting. As Picasso said, "You have to grab people's interest; you have to prevent that man or woman from glancing past the painting." All of Picasso's works are brilliant examples of variety within unity.

Sometimes all you need to do is look at the subject from a different angle in order to eliminate excessive symmetry.

Another important component in a painting is form. The German philosopher Fechner was the first person to study the physical and psychological connotations of form. He once collected a group of images in three categories: natural (the silhouette of a hand, a head, or the leaf of a tree); abstract; and geometric. Fechner then picked a group of people at random and asked them, "Which among these designs do you consider the most pleasant and harmonious? Which do you like best?" The answer showed that geometric designs attract the most attention, are looked at the longest, and are easiest to remember.

Theoreticians of form think that the appeal of certain designs is due to the hedonistic principle: We naturally seek maximum satisfaction with a minimum of effort—in this case, a minimum of muscular or mental energy. It is interesting that artists have always used geometric designs as outlines in artistic composition.

But we shall see more of this in the following pages.

Fig. 12. The house reproduced in figure 12 A in an example of symmetrical composition, synonymous with unity. The asymmetrical composition of figure 12 B obtains variety without losing the unity of the whole.

Fig. 13. These silhouettes reproduce the designs that the German philosopher Fechner used in his famous research to determine the physical reactions they provoked in a group of people. The people he tested clearly preferred the geometric designs, followed by (in order of preference) the natural and the abstract ones.

Using geometric form to unify structure

14

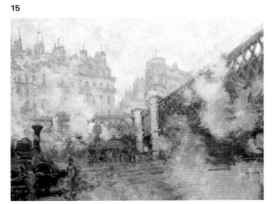

15

14A

In effect, basic geometric shapes like the triangle, rectangle, pyramid, or sphere can be seen in many paintings like those illustrated on these pages.

Composition in the form of a triangle or rectangle is a formula that is called Rembrandt's because the artist made use of it in many of his figure paintings. The pyramid form appears in many Renaissance paintings, particularly in religious themes worked in symmetrical compositions. This same compositional form was used as a classical model in the time of the French painter David. The critic Bousset once said that this pyramidal compositional form was almost the only one in the Rome shows (academic shows leading to study funds or grants). The rectangle, the semicircle, the circle, and shapes of letters like L, C, and Z also help the structure of a painting by enhancing its structure unity.

But you have to be able to look for these and other forms. You must stand before the subject or landscape and look carefully with half-closed eyes, trying to see past the details to the essential form. Occasionally the basic form is easily seen, but more often it is less obvious. Then the artist has to interpret and compose, bearing in mind that fundamental norm dictated by the artist André Lhote, the author of *Traité du Paysage:* "To interpret and compose, the artist must exaggerate, enlarge, reduce, omit, whether with lines, shapes, values, or colors."

16

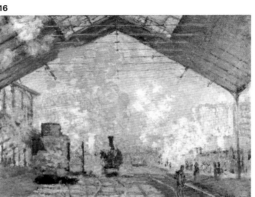

17

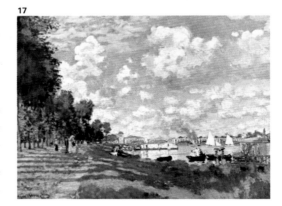

Figs. 14 to 17. John Constable (1776-1837), *Landscape at Noon*, National Gallery, London. Claude Monet (1840-1926), *Pont d'Europe, Saint-Lazare Station*, Marmottan Museum, Paris; *Saint-Lazare Station*, Orsay Museum, Paris; *The Argenteuil Pond*, Orsay Museum, Paris. Constable was one of the most important English landscape artists of the nineteenth century and Monet was considered the most authentic impressionist. Despite their very distinct styles, both painters used classical geometric compositions that are still used by artists today.

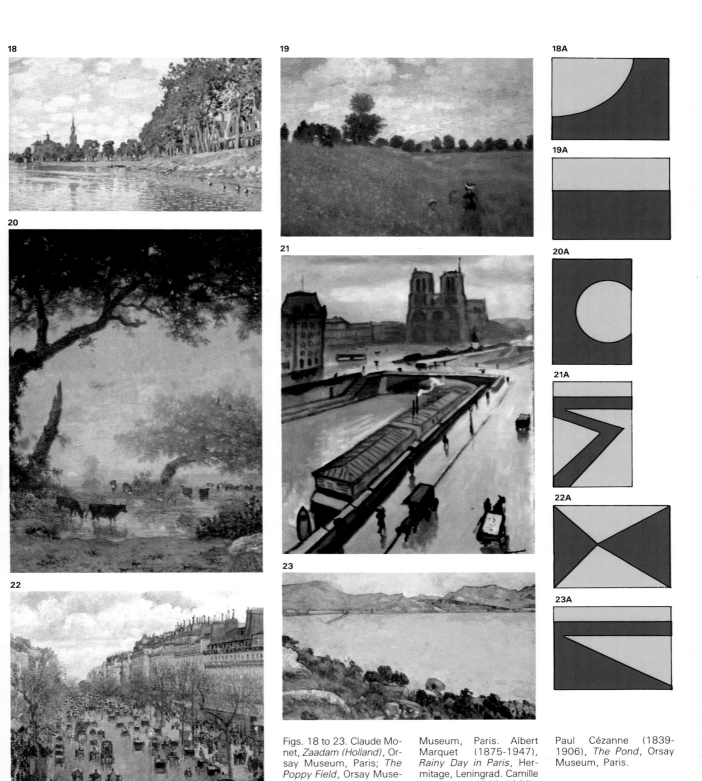

Figs. 18 to 23. Claude Monet, *Zaadam (Holland)*, Orsay Museum, Paris; *The Poppy Field*, Orsay Museum, Paris. Theodore Rousseau, *Woods at Fontainebleau, Setting Sun*, Louvre Museum, Paris. Albert Marquet (1875-1947), *Rainy Day in Paris*, Hermitage, Leningrad. Camille Pissarro (1830-1903), *Boulevard Montmartre*, Hermitage, Leningrad. Paul Cézanne (1839-1906), *The Pond*, Orsay Museum, Paris.

Creating similarities to enhance variety

24

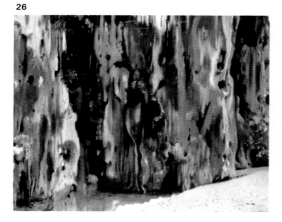

25

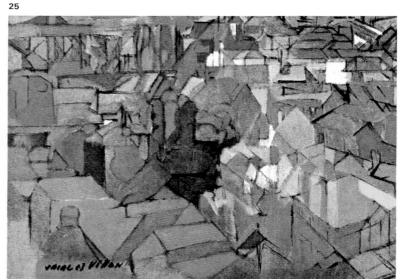

26

27

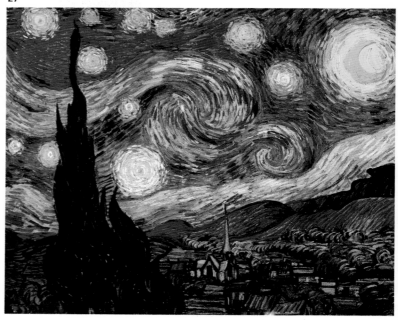

It may sound strange to achieve variety by creating similarities. But in fact, repeating patterns and distributing them throughout a painting forms a kind of echo that enhances the focus of color, shape, and style. It is the famous law of repetition, by which greater harmony and a better order within the variety of the composition are obtained.

You can see some examples typical of the creation of similarity in the pictures on this page, achieved through the deliberate repetition of colors, shapes, tones, and lines.

Figs. 24 to 27. Vincent van Gogh (1853-1890), *In the Woods*, Rijksmuseum, Amsterdam. Jacques Villon (1875-1963), *The Small Town*, private collection. Joaquin Mir (1873-1940), *Cave*, private collection. Vincent van Gogh, *Starry Night*, Museum of Modern Art, New York. Here we see several examples of an important device for achieving variety in a painting: the creation of similarities in the arrangement, size, or color of the forms. The repetition of patterns helps achieve variety within unity.

Contrasting tone to create variety

In these landscape paintings, Monet and Constable offer us extraordinary effects of contrast in tone that attract our attention, awaken our interest, and create a visual impact. But see how this variety is not overdone to the point of distracting us, because a counterbalancing unity is also achieved. There is no contrast of color, only of tone. Above all, the geometric structure lends a sense of unity and balance, particularly in the two Constable paintings and in *Saint-Lazare Station* by Monet.

29

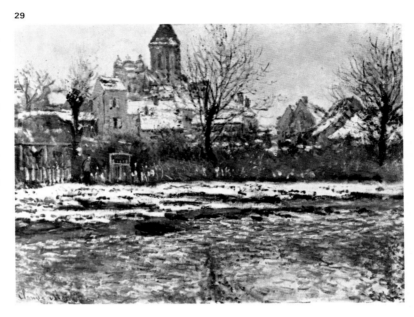

28

30

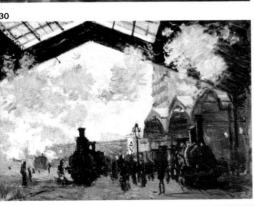

31

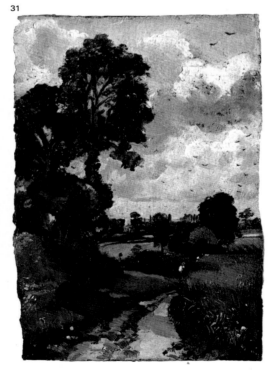

Figs. 28 to 31. John Constable (1776-1837), *View of the Stour: Dedham Church in the Distance*, Victoria and Albert Museum, London. Claude Monet (1840-1926), *Church of Vétheuil*, Orsay Museum, Paris; *Saint-Lazare Station*, Orsay Museum, Paris. John Constable, *Stoke/Nayland*, private collection. Observe the tonal contrasts used by Constable and Monet in the paintings reproduced on this page. They create variety without breaking the unity of the picture.

Contrasting color to create variety

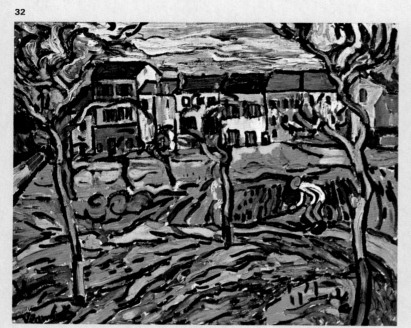

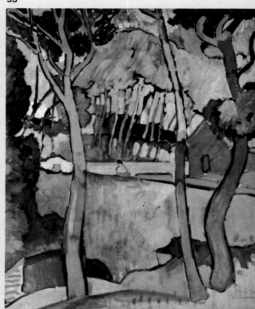

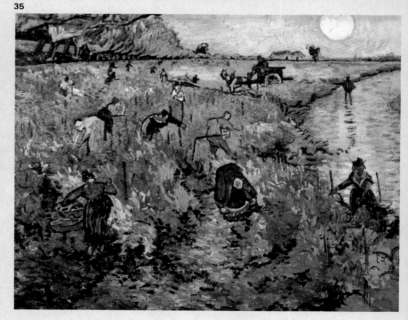

Toward the end of the nineteenth century, a group of painters that included Bonnard, Vuillard, Maillol, and Denis founded the Nabis movement (from the Hebrew for Prophet). The Nabis defended pure, flat colors. Maurice Denis, the theoretician of the group, would say: "Remember that a picture, before being a horse, a nude, or some kind of anecdote, is essentially a flat surface covered with colors assembled in a certain order."

Shortly afterward, in 1905, another group of painters (among them were Matisse, Derain, and Vlaminck) held an exhibition at the Autumn Salon in Paris. Because their canvases were painted in strange, flat shapes and horrendous violent colors, the group was dubbed Les Fauves (wild beasts). The Fauvists discovered the effect of juxtaposing complementary colors and painted color contrasts more striking than any seen before.

Figs. 32 to 35. Maurice de Vlaminck, *The Gardens at Chaton*, Chicago Art Institute. André Derain, *The Pond, Three Trees*, Zacks Collection, Toronto; *Mountain Path*, Hermitage, Leningrad. Vincent van Gogh, *Red Vineyards in Arles*, Pushkin Museum, Moscow.

36

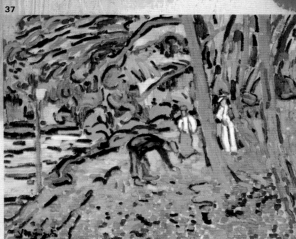

37

Figs. 36 and 37. Paul Sérusier (1863-1927), *Scene at Woods of Love*, M. Deni Collection. Maurice de Vlaminck, *Scene at Dead Forest*, private collection.

38

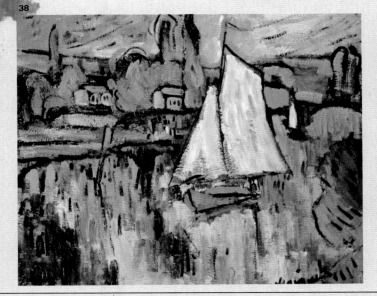

39

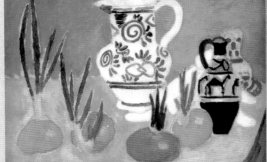

Figs. 38 and 39 Maurice de Vlaminck, *View of the Seine*, Hermitage, Leningrad. Henri Matisse (1869-1954), *Red Onions*, Statens Museum of Art, Copenhagen.

Framing the subject to achieve variety

When you are about to begin a landscape, have you ever asked yourself whether you could frame your subject in a completely novel way, ignoring the rule of the golden mean completely?

Well, the impressionists certainly did. But the idea and the question came to Europe from the Japanese. Japanese art made its first Western appearance at the World's Fair Exhibition in 1855. Pissarro commented, "A marvelous Japanese exhibition. Myself, Monet, and Rodin are excited." Almost at the same time, a small shop on the rue de Rivoli called Portechinoise began selling collections of plates and prints by the Japanese artists Hokusai and Hiroshige. The flat colors, linear drawings, and unusual placement of subjects astonished the young French painters. But perhaps it was Degas who knew best how to interpret his study of Japanese art. They decentralized the frame from then on, placing his figure and forms to one side —even cropping parts of them off— and freezing movement and expression. Many of his paintings resemble a fleeting photographic instant.

Any painter can benefit from following the impressionists' example and experiments with unusual ways to frame the subject within a painting. For instance, the horizon line does not necessarily have to be situated above the middle of the canvas, or exactly at the level of the golden mean. There is no reason why it should follow norms and traditions; it can be different to create variety.

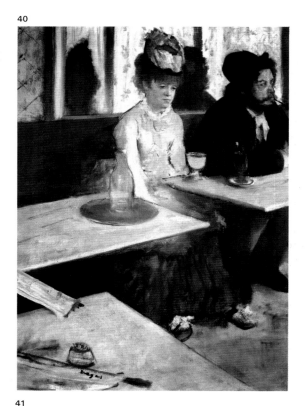

40

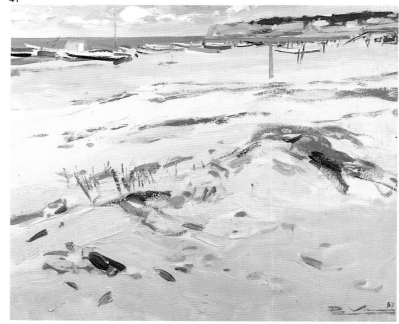

41

Fig. 40. Edgar Degas, (1834-1917), *The Absinthe Drinkers*, Orsay Museum, Paris. Impressionism brought about a revolution in painting —not only in the use of color, but also in the treatment of composition. The impressionists did not hesitate to decentralize the subject or cut part of it out of the paintings altogether. A classic example is this painting by Degas, who was especially preoccupied with framing subjects in innovative ways to make his compositions.

Fig. 41. The painting reproduced on the right is by Pere Lluis Via, a present-day painter who specializes in landscapes and seascapes. He has distorted the proportions, inverting and exaggerating the relative terms of the golden mean, to achieve variety in the frame.

Creating variety through texture

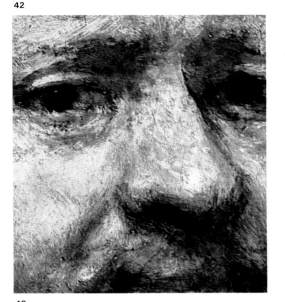

42

If you ever have the opportunity to take a close look at the original Degas painting of *The Absinthe Drinkers* (reproduced in figure 40 on the facing page), you will be surprised at how thin the paint is, so that the texture of the canvas is totally visible. Nearly all the canvas is worked with sparse paint mixed with abundant turpentine, with brushwork that allows the grain of the material to show through.

In contrast, if you could see close up the other paintings reproduced on this page, you would be surprised at the thickness of the paint. Some areas of the pasty texture is like a bas-relief. There is an amusing anecdote about Rembrandt. In Amsterdam the running joke was that Rembrandt's portraits could be hung by the nose.

It is undeniable that the texture of the paint itself, whether thick or thin, can be used to accentuate the variety in the composition of a painting.

The last few pages have given you a few ideas about how to compose a painting. But the art of composition is much more complex; it is not resolved with an outline or a frame, contrast or texture. Like drawing figures or mixing colors, it requires constant study and practice. It is also essential to study the paintings of the great masters, both old and new. Attempt to find within them that variety within unity that is so elusive, so subjective, but that does in fact exist. It also exists in any landscape you have the urge to paint, quietly waiting for you to discover it and transfer it onto the canvas.

Figs. 42 and 43. Rembrandt (1606-1669), *Self-Portrait of the artist at sixty-three years old* (detail), National Gallery, London. Claude Monet (1840-1926), *Rouen Cathedral in Full Sunlight*, Orsay Museum, Paris. Rembrandt and Monet painted the pictures reproduced on this page with thick application of color; Degas painted *The Absinthe Drinkers* (fig. 40) with a very thin layer of paint. Texture is one of many ways to create variety within unity.

43

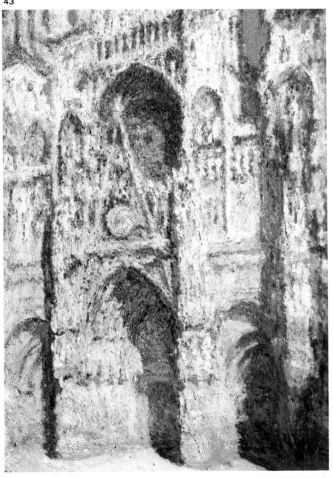

The artist, the subject, the materials

44

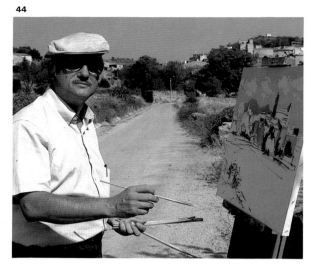

Fig. 44. Here is the artist Gomezvellvé, landscape artist and teacher of drawing and painting. He has won prizes and exhibited his work in several countries. For this book he has painted a rural landscape.

45

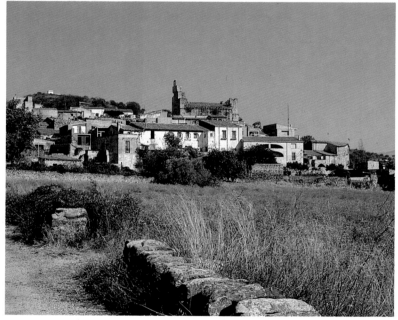

Figs. 45 and 46. This is the subject Gomezvellvé is going to paint in oil: a composition reminiscent of the work of Corot and Pissarro. Pissarro superimposed successive foregrounds to obtain a three-dimensional effect. In the photograph below, Gomezvellvé has set up his easel in the shade to prevent the direct sunlight from distorting the colors.

46

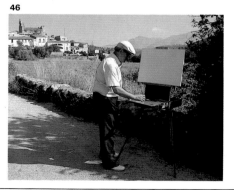

Ezequiel Gomezvellvé is a professional artist whose speciality is landscapes in oil. A private teacher of drawing and painting, he has won prizes and held exhibitions in various countries and is now working on the paintings for his next one. He works in the extreme north of the Costa Brava in northeastern Spain, near the French border.

"It's an ideal place to paint landscapes in oil," explains Gomezvellvé, "a place with a variety of subjects on small, nearly deserted coves where old fishermen work on their boats. Inland toward the mountains a little farther from the coast, it is easy to find old villages with church spires pointing up over roofs and windows."

Gomezvellvé has chosen one of these little villages as the subject of his landscape in oil (fig. 45). The scene is a bit like the paintings of Corot and Pissarro.

Gomezvellvé has set up his easel, a typical folding one, by the side of a path next to some tall bushes. I ask him, "Isn't it difficult for you to paint in the shade where all the colors are somewhat blue?"

Gomezvellvé is placing the canvas, a number 10 figure, and responds: "No, exactly the opposite. Under sunlight conditions, contrast is so intense that color vision becomes distorted, but when you look at the picture under normal lighting conditions, indoors for example, the colors appear more intense."

Gomezvellvé uses good-quality oil paints and an assortment of flat, round, and filbert paintbrushes ranging from number 6 to number 14. He uses solvents like turpentine and linseed oil, each in its own watertight container, in which he dips his brush now and then. He also uses a palette knife to clean the palette, and he cleans the brushes by scrubbing them with an old cotton cloth.

Figs. 47 to 49. As you can see from these selected paintings by Gomezvellvé, our guest artist is an admirer of the impressionist style, whose approach is realistic at the same time carefree and spontaneous. Notice Gomezvellvé's handling of the main themes, the sense of depth in his paintings, and the color harmony.

47

48

49

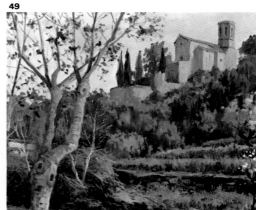

First stage: The drawing

Gomezvellvé draws the picture with a gray color made up of raw sienna, ultramarine blue, and white —much diluted with linseed oil and turpentine. He uses a number 6 flat brush, which he holds near the end of the handle (fig. 50). Strangely enough, Gomezvellvé does not begin with outlines or points of reference that mark the proportions, nor does he do a rough sketch like so many artists do before beginning the actual drawing. In fact, Gomezvellvé does not make any previous calculation— except in his head. Before starting the painting, he concentrates for a while on the subject, scrutinizing the houses and the field from one side to the other. His hand and brush are pointed at the canvas until he suddenly begins to draw everything without stopping. Working swiftly and surely from left to right, he outlines the proportions of each form, tree, and house, until the whole village has been sketched on the canvas.

Notice that Gomezvellvé's composition comes very close to following the rule of the golden mean. His village is located almost ideally from an aesthetic point of view (fig. 52).

50

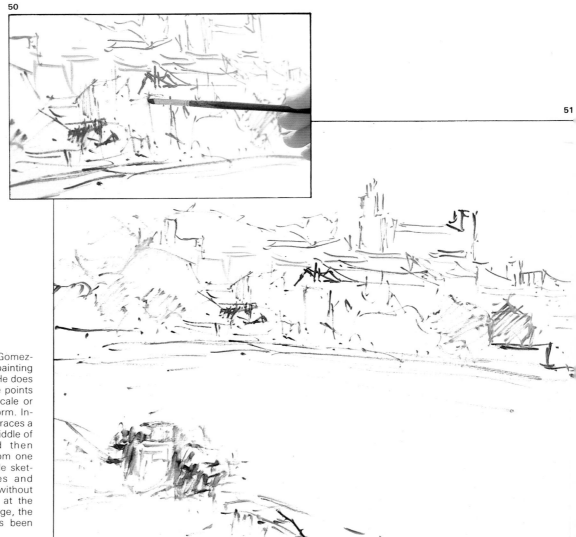

51

Figs. 50 and 51. Gomezvellvé begins his painting in a striking way. He does not note reference points or mark out the scale or position of each form. Instead he decidely traces a line through the middle of the canvas and then draws, moving from one side to another. He sketches in the trees and houses almost without stopping, so that at the end of this first stage, the whole subject has been drawn.

Second stage: The sky and the shadows

The sky comes first. Like Sisley, Constable, Monet, and countless others, Gomezvellvé feels the need to fill in spaces. He starts by painting the sky, and from the first, he leaves blank spaces to suggest the shapes of clouds that he will develop in more detail later.

Then come the shadows, which add a sense of depth.

From left to right as before, as if he were continuing to draw, Gomezvellvé now draws and paints in the shadows, giving volume to his subject. He mixes different hues to diversify and enrich the colors of the shaded areas, which are in reality quite diverse.

I am still thinking about the golden mean. I have a tape measure in my car so I go and get it. "I'm curious," I tell Gomezvellvé, to see how far from the golden mean you've situated the roofs of the village."

I measure the height of the canvas: 18 1/8 inches (46 cm). I multiply this by 0.618 and get about 11 1/4 inches (28 1/2 cm). A line across the canvas at this height would coincide with the roof of the church building. (See fig. 52, in which the red line marks the location of the golden mean.)

"It can be said that you took the golden mean into account," I tell him.

Gomezvellvé becomes enthusiastic; he likes this subject: "And I didn't calculate anything beforehand. But it's not a coincidence, you know. That aesthetic feeling for the golden mean is something you have inside you. It's instinctive."

It's the ideal location for the subject of a painting, tried and tested after creating hundreds of pictures.

Figs. 52 to 54. Gomezvellvé first paints the sky to avoid false contrasts. "You should fill in the canvas as soon as possible to balance out the ensemble of colors," he explains. He then continues with the shaded areas which he paints in different colors.

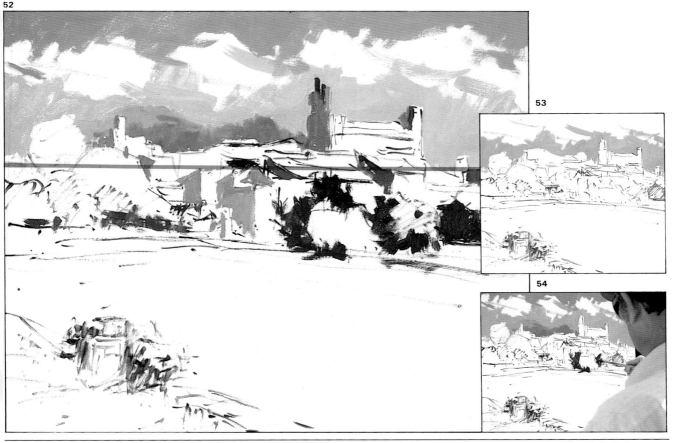

Third stage: Painting alla prima

With his characteristic speed, Gomez-vellvé paints the shapes and colors of the houses alla prima, quickly conveying light and shade, roofs, walls, windows, and trees. He is highly skilled at synthesizing the group of village buildings.

Next he paints the field that makes up the bottom half of the composition. (See this process step by step from the pictures on page 21 starting with fig. 56, which shows a photograph of this part of the painting).

The first step is to apply color with horizontal brushstrokes that practically cross the canvas from side to side (figs. 57 and 58). Note that the color of these strokes is not uniform, but varied. The different colors emphasize the feeling of depth. Soon Gomezvellvé interrupts these horizontal strokes to work on the grass with thick vertical brushstrokes that create diversity and better represent the general roughness, hues and textures of the countryside.

When Gomezvellvé nears the foreground of the field, he paints with much darker colors. This creates a contrasting backdrop for the long pale grass that he will add later in the immediate foreground (figs. 60 and 61).

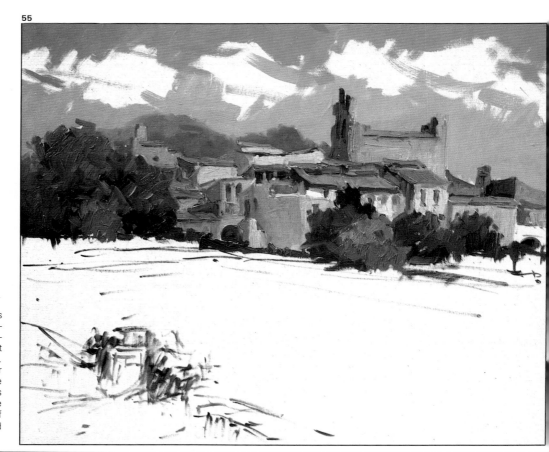

Fig. 55. In Gomezvellvé's determined way of painting, the artist's personal interpretation of the subject has a decisive influence. Having put in the major dark areas in the last phase and the colors of the roofs and houses in this one, he has worked the upper half of the painting by the end of the second stage.

The way of the stroke

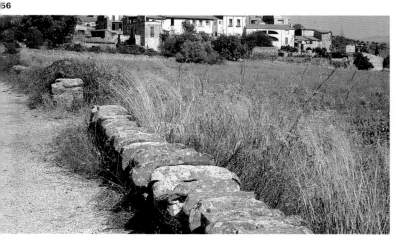

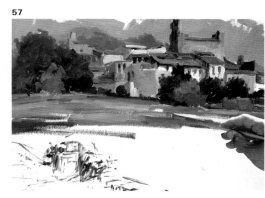

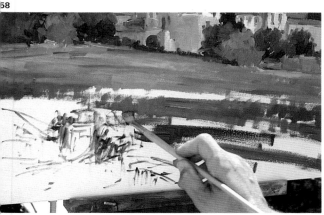

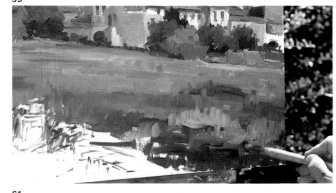

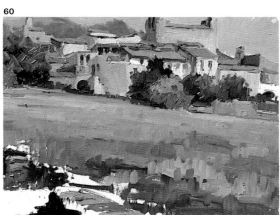

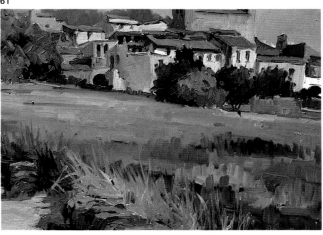

Figs. 56 to 61. From the sequence of photographs on this page, see how Gomezvellvé paints the field in the lower half of the painting: first he uses horizontal brushstrokes with different tones, over which he later applies thick vertical strokes that suggest the form of the grass (figs. 58 and 59). Look at how in figures 60 and 61, Gomezvellvé achieves depth in the picture by painting the foreground grass in lighter tones over the shading of the grass behind it. As you may know, warm colors bring the foreground closer to the viewer's eye.

Gomezvellvé's color range

Gomezvellvé picks up the palette knife to clean his palette. "No, wait," I tell him. "We're going to take a photograph of this palette so that we can talk about color and the range you use in your paintings."

Gomezvellvé now begins to explain much as he does in his drawing and painting classes.

"For me there are four basic colors: cadmium yellow, madder, Prussian blue, and emerald green. The latter is obtained by mixing the yellow and the blue, but I prefer to think of it as a basic color because of its ability to enrich the green and blue ranges and even the sienna and earth colors. For me the ideal palette of colors is made up of the more subsidiary ones of lighter and darker hues, like deep ultramarine blue with sky

blue; permanent green coupled with emerald green, and so on. I add raw sienna to this collection and a violet color—permanent violet."

"Why use permanent violet if you can mix it from blue, carmine, and red?" I ask.

"I don't know. I've gotten used to this color now and I think it's essential for making something appear grayer, for mixing the colors of certain shadows, for creating shade in the background and atmosphere and space in general."

Fig. 63. Look at the composition and mixture of colors used by Gomezvellvé in his landscape in oil. The enlarged details show how he mixed the colors on his palette to achieve the diversity of colors evident in this third stage.

62

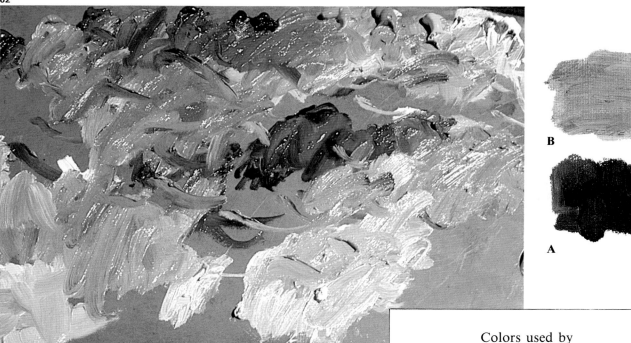

B

A

Fig. 62. This is Gomezvellvé's palette: a range of neutral colors tending toward warm. None of his colors are bright or harsh.

Colors used by Gomezvellvé	
Titanium white	Carmine madder
Lemon yellow	Permanent violet
Yellow ochre	Emerald green
Raw sienna	Permanent green
Cadmium orange	Ultramarine blue
Cadmium red	Sky blue

A. *Permanent green and cadmium orange*

B. *Cadmium yellow, lemon yellow, sky blue, carmine madder, titanium and white*

C. *Emerald green, yellow ochre, and titanium white*

D. *Ultramarine blue, yellow and cadmium red*

E. *Ultramarine blue, cadmium red, lemon yellow, and titanium white*

F. *Yellow ochre, sky blue, and titanium white*

G. *Ultramarine blue and titanium white*

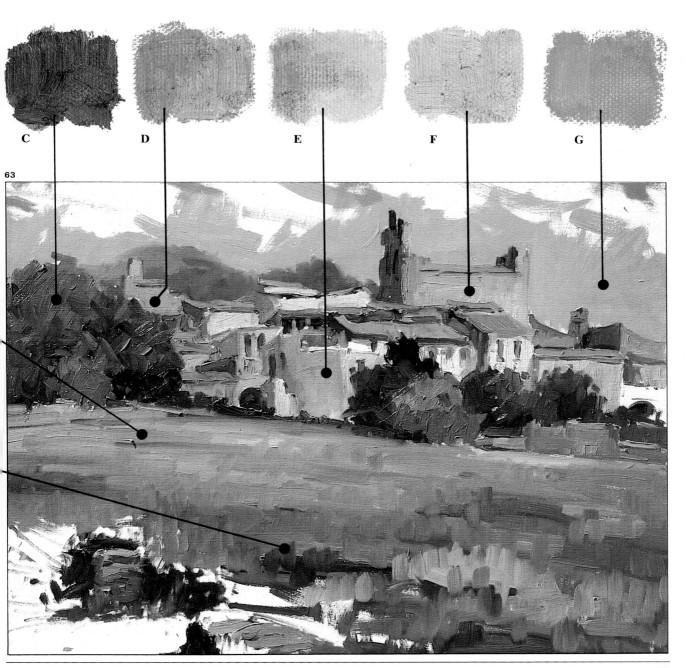

C **D** **E** **F** **G**

63

Fourth stage: End of the first painting session

Fig. 64. To paint the long grass in the foreground in light colors over a dark surface, which we commented on in figures 60 and 61, Gomezvellvé holds a sable brush near the end of the handle and paints with rapid strokes. He also uses a more diluted paint so as not to disturb the thicker color of the first layer.

Fig. 65. Gomezvellvé now paints the light and shade of the clouds, which he left as blank white canvas earlier. To paint the shade, Gomezvellvé models the shape of the clouds using permanent violet, a color whose transparency he considers necessary to depict clouds in a pale blue summer sky.

64

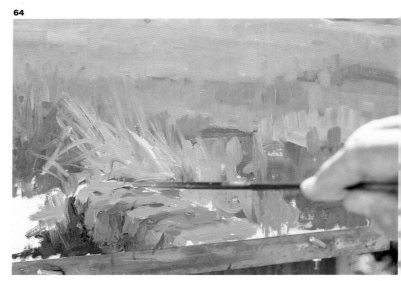

65

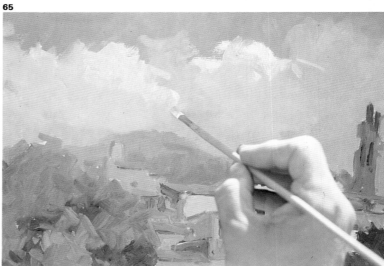

The basic differences between the third and fourth stages of the painting are the completion of the boulders in the wall on the edge of the path, the addition of the yellowish color to the long grass, and the depiction of clouds with the corresponding play of light and shade.

Gomezvellvé paints the long grass in the foreground with yellow ochre brushstrokes applied over a recently painted surface, which can be seen in figure 63 of page 23. In order to put the finishing touches on the forms and colors of this yellowish grass,

Gomezvellvé practices several tricks of his trade. In the first place, he works with a soft-bristled sable brush, which enables him to paint with clean strokes and prevents the dark colors of the background from bleeding into the lighter ones of the grass. He also uses slightly more liquid paint, so that he can apply light colors over wet dark ones. And finally, Gomezvellvé works with quick brushstrokes, dabbing the brush from top to bottom and holding it near the end of the handle apply those rapid, "spontaneous strokes" (fig. 64).

66

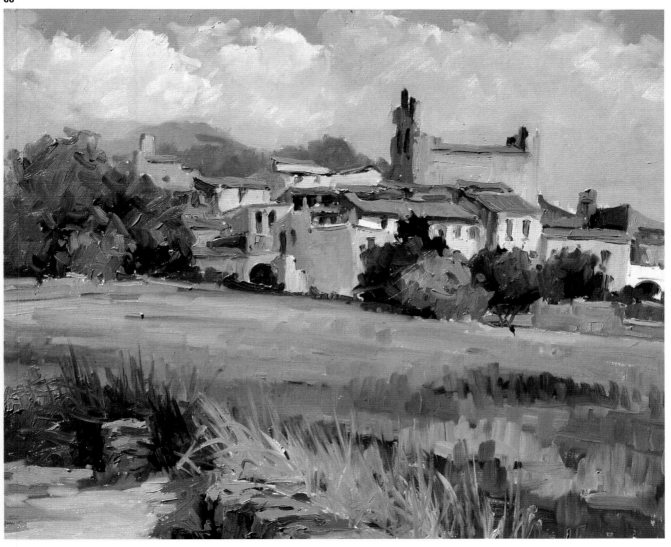

Having reached the stage of the painting shown in figure 66, Gomezvellvé ends the outdoor painting session and proceeds to put away his palette and other supplies. He explains "To finish a landscape properly, you should put on the last touches one for two days later, when the oil is still ('al dente'—) that is, when it is almost dry so that you can repaint on top with clean colors." And he cleans the palette one last time, saying, "I'll finish it at home in my studio."

He looks at the painting from a certain distance and adds after a pause, "The foreground needs more contrast."

Fig. 66. This is what the painting looks like when Gomezvellvé decides to end the first session. He will rework it in the studio when the colors are drier, which will allow him to paint without the immediacy that the alla prima technique imposes.

Fifth stage: The finished painting

67

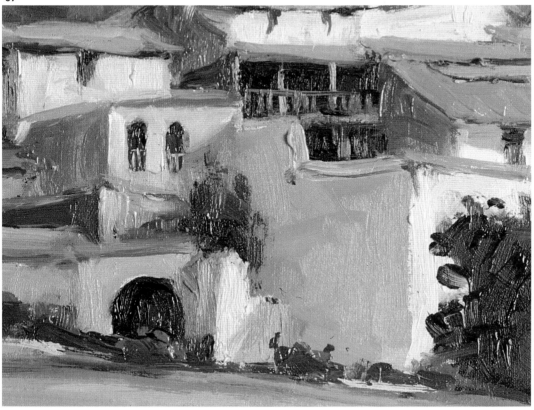

68

The last of Gomezvellvé's, sessions in the studio has been really fruitful.

"Yes, the truth is that when I got home with the idea of finishing the painting by retouching it, I got excited and spent a wonderful morning remembering the subject and redoing practically all the colors in the painting."

I cannot help myself telling him, "You have managed to refine the painting without falling into the trap of appearing too fussy or affected. But most of all, you have achieved a perfect harmony of luminous colors."

Figure 67 shows an enlarged detail of the finished painting in which the quality of the brushstrokes, the sense of depth, and the perfectly harmonized color range can be fully appreciated.

Gomezvellvé's painting is a good model of how to paint a landscape in oil. In the studio, with the finished painting on the easel, he puts his signature on it.

Then he walks away from the canvas.

"Well?" he asks, still looking at it, "what do you think?"

"Very good. I think what we have here is a fine example of how to paint a landscape in oil."

Figs. 67 and 68. In the studio, Gomezvellvé has not merely put the finishing touches on the painting. In fact, away from the subject, our guest artist has produced yet another interpretation of it, emphasizing the more figurative elements and relying on the use of warm colors in

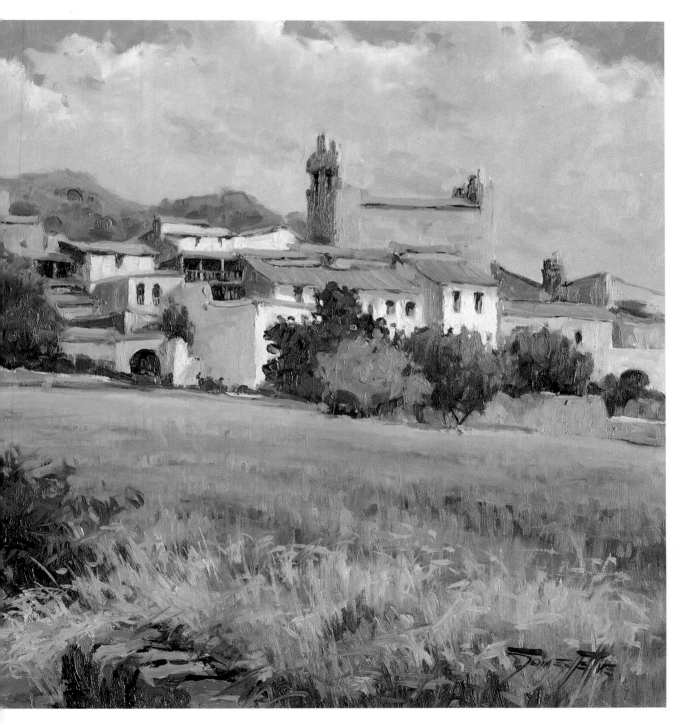

the foreground to accentuate the depth of the composition. He has also lightened the roofs of the houses to distinguish the outlines of the different shapes. Note the quality of the brushwork to bring out the volume of the buildings in figure 67, and note how he has also painted the background mountains in blue to create a three-dimensional effect. Finally, in interpreting the subject, the artist has designated the bottom half of the canvas to the field and placed the village in the middle ground. Gomezvellvé's painting is a useful lesson on how to paint a landscape in oil both for its composition and for its color harmony.

The studio and the materials

69

Josep Verdaguer lives and works in Barcelona, where he was born in 1923. The studio in which he has painted for 35 years is near his home and was built especially for him by the owner of the property, a personal admirer and art enthusiast who had faith in him as an artist and decided to have a studio built to his friend's own specifications so that he could work there comfortably.

Verdaguer is internationally known. He has exhibited all over Spain as well as in such cities as Paris, Stockholm, Chicago, Tel Aviv, and Grenoble. He has also produced murals for various churches in Catalonia and for the airport in Barcelona.

Verdaguer's studio has a large window facing south, a small one on the same side, and another small window facing east. The large window is screened off to prevent direct sunlight from hitting the canvas when he paints.

70

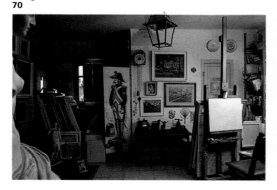

The room measures approximately 23 × 26 feet (7 × 8 m). In direct contrast to the lighting in, say, Vermeer's paintings, the light here comes in from the right, at least on this occasion, as you can see from the photograph.

To the right of the easel is a large number of brushes. Just beneath the easel, on a little table, are the brushes, the tubes of oil paint, and the palette Verdaguer is going to use. There are a few more tubes on the easel shelf.

71

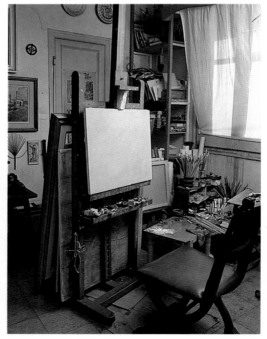

Figs. 69 to 71. Josep Verdaguer, a well-known artist, will paint a landscape in oil based on various rough notes he has in his studio for other paintings. It is a spacious studio, typical of the professional painter. We can see the classic studio easel holding the canvas prepared with a layer of light ochre. The easel tray and the square table are full of paints, brushes, and so on.

The choice of subject

Verdaguer's sketches

Although he paints medium-size canvases on location outdoors, Verdaguer likes to make sketches (on paper or board with oils and on paper with watercolors) during his many trips.

The artist has so many sketches that when the time comes to choose one to develop before us, an embarrassment of riches harshly presents itself. Which one to choose?

Since this book deals fundamentally with rural landscapes, we begin by casting aside the urban scenes and seascapes. But even so, there is a wide choice of possible subjects.

Verdaguer sorts through them. The crossing keeper's hut is discarded on the grounds of there being too much anecdotal illustration for a teaching session —and there is the added danger that the challenges of drawing the subject will prevent him from concentrating on the strictly figurative. Conversely, the high mountain landscape is rejected because its harmony of green and earth colors is too pleasing and presents no special difficulties.

The refreshment stand at the beach is, when all is said and done, a seascape; the field of flowers (fig. 76 on the next page) runs the risk of becoming too "pretty."

Figs. 72 to 75. Here are some of Verdaguer's fine oil sketches. He proceeds to select one from which to paint a definitive landscape in oil.

72

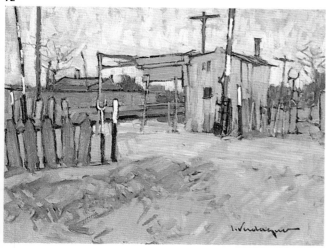

73

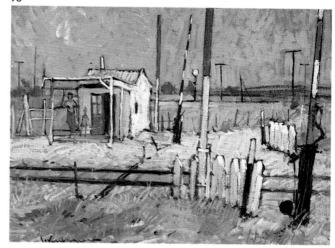

74

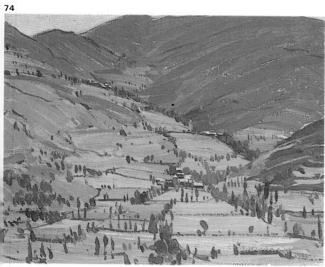

75

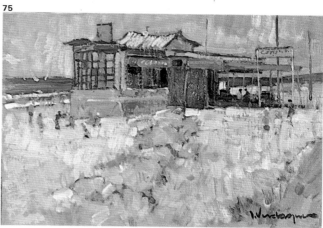

A painting based on a sketch

One sketch still remains: Verdaguer has chosen a field with bushes and flowers (fig. 77).

It is strictly rural, and contains a wide range of colors —but all of them are fairly dull. The composition is daring without seeming contrived, and the flowers are important but do not outweigh the rest of the components.

"However," says Verdaguer, "the main reason for choosing this sketch is that the problems it presents are mainly pictorial ones." That is, there are no houses, people, or other immediately recognizable, representational forms; it is pure painting.

Try this test: Look at the sketch and forget for a minute the mention of flowers, a field, and a tree. Consider the lower half as an area of fairly neutral tones, the flowers as mere points of light, the tree as a dark smudge, and the sky as a light fringe. In other words, imagine that you find yourself before an abstract painting. The remaining problems of form, color, proportion, brightness, tone treatment, and composition are all, as Verdaguer says, purely pictorial.

The Palette

Verdaguer likes to use different brands of oil paint. He has no reservations about combining them.

76

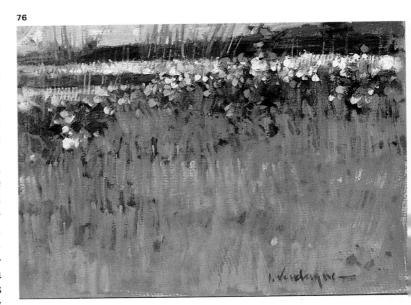

77

This is the palette.
From left to right:
Titanium white
Lemon yellow
Cadmium yellow deep
Raw sienna
Burnt sienna
Vermilion
Cadmium red
Ultramarine blue
Green
Black

78

Figs. 76 and 77. These ar two more sketches fror the initial selection. Th one Verdaguer finall chooses is shown in figu 77.

Fig. 78. Here are Verd: guer's palette of colors an assortment of brushes.

First stage: The focal point

Verdaguer primed his canvas earlier with a layer of very light ochre, which is now dry. "For color harmony, it is better not to start with pure white," he says.

Although he has turpentine in a bowl at one corner of the palette, Verdaguer does not use it to thin the color. But he does not work with thick blobs of pure color either. Instead the painter picks up a very worn sable brush, seemingly triangular in shape but actually flat. With it he takes a small amount of pure color and starts rubbing — almost scraping— it across the canvas.

At the outset, he has made up a slightly dull blue color, with which he has "attacked" the main subject of the canvas with no previous rough outline. And the word "attacked" could not be more appropriate, since Verdaguer claws at the canvas with his brush almost frenetically, with much energy and determination.

He looks at the sketch and mixes some more colors on his palette: blue, earthy hues and dull greens. You can see our earlier prediction coming true: Verdaguer is establishing visual relationships using mass, color, tone, and value without having first planned a general structure. The painting emerges as one paints.

Verdaguer has already located the focal point of the painting using only blue, earth colors, and green. All this area has been worked with his old number 7 flat sable brush, which, as already mentioned, is so worn away at the edges that it is almost triangular.

You can see that the off-white color of the canvas, which Verdaguer uses as a starting point, already enhances the harmony of the dull, neutral tones.

Figs. 79 to 81. Verdaguer directly paints and draws the initial layout of the picture in oil on to the canvas. And he does so bearing in mind the colors the subject affords and the structure and drawing of the painting.

79

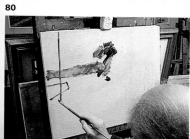

80

81

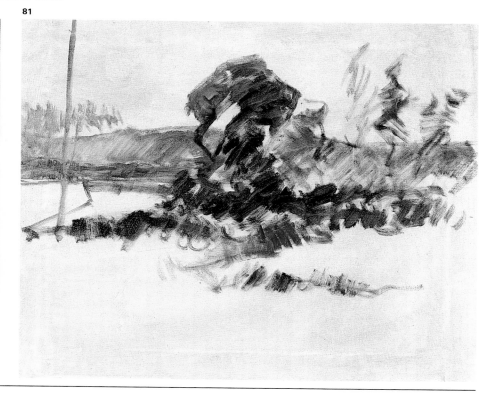

Second stage: The foreground

Verdaguer now fills in the lower section of the canvas, which accounts for two-thirds of the painting. Now he is using wider, less worn sable brushes, from number 14 to number 16. He applies an assortment of dull siennas, burnt umbers, reds, and yellows to the canvas. Not a single color is clean, pure, or brilliant.

Note how in the lower section, especially on the right side, the brushstrokes are still lively but appear less distinct because the paint has been thinned down with turpentine.

At this stage, Verdaguer rubs the colors onto the canvas rather than almost scratching them on, as he did earlier.

82

Figs. 82 and 83. These pictures show that Verdaguer fills in space right from the start, to eliminate the emptiness of the blank canvas—in this case, with a pale ochre color. His technique of rubbing on paint with barely any solvent— and of using it to draw and paint at the same time —can also be seen.

Figs. 84 and 85. Step by step, the painting progresses. By the end of the third stage, the forms and colors of both sky and background are virtually finished.

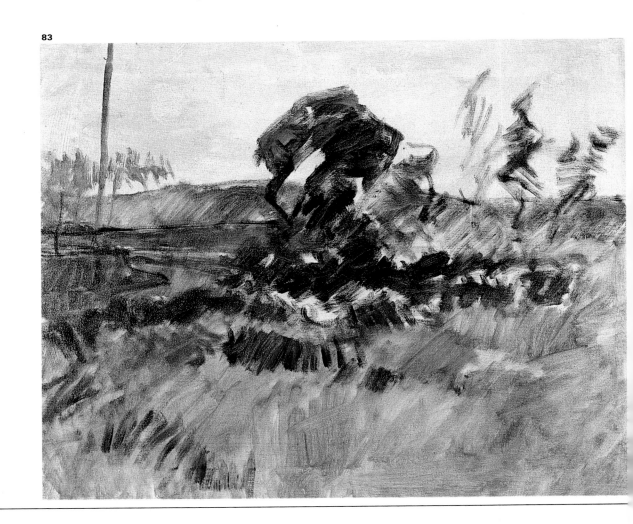

83

Third stage: The sky

Verdaguer begins to add yellow to the upper part of the canvas. This color dominated the sky in the sketch and will also prevail in the finished painting. However, he also adds vigorous brushstrokes of blue and a yellowish white on the right side, which were not in the original sketch.

The three saplings at the right, which until now were only sketched in blue and green, have been redone in sienna. At this stage of his work, Verdaguer also marks out a clean new vertical line in the upper left, which stands out as one of the few specific supporting figures in the composition.

He has been using a variety of brushes — new and old, wide flat ones and pointed ones for details.

By now the entire canvas is covered, and all the essential relationships have been established.

84

85

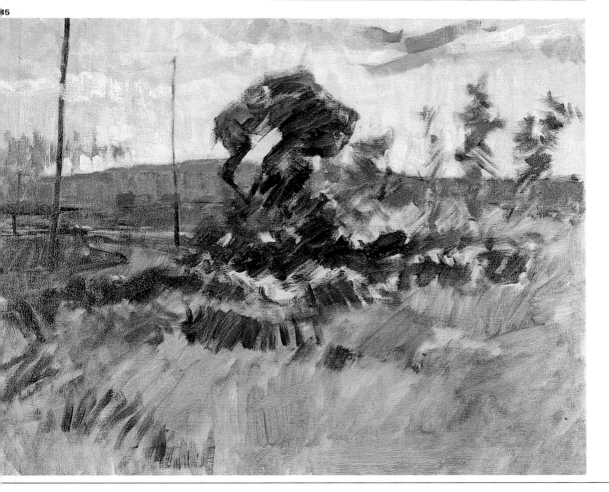

Fourth stage: Parallels with Mir and Nonell

Mir and Nonell are among Verdaguer's favorite Catalan painters, both of them born in 1873. However, in his studio, he also has a book of illustrations done by Norman Rockwell for *The Saturday Evening Post:* "Rockwell was very interesting; as an illustrator he was unique," pronounces Verdaguer while continuing to paint. But many more of the artists he admires are represented in his studio, ranging from van Gogh to Picasso.

Verdaguer's painting has been defined as romantic by some critics. "But I prefer to consider myself in some ways an impressionist," he says.

Remember how we stated earlier that Verdaguer's sketch could be interpreted as abstract? Look at a reproduction of one of Joaquín Mir's paintings (fig. 86), a landscape that could also be construed as a nonrepresentational painting. Now look at the stage of Verdaguer's painting shown in figure 88. If we were to forget what objects are being suggested here, we find ourselves before a mere relationship between forms and colors. Even the two telegraph poles in the upper left could be considered simply two vertical lines.

The parallels between Verdaguer and Isidro Nonell are even more evident and have to do with surface texture. The visual style of Nonell probably stems from Monet and Daumier, but more directly from Toulouse-Lautrec. It is based on short, distinct brushstrokes, nervously repeated. Compare Nonell's painting (reproduced in fig. 87) with this stage of Verdaguer's painting: The similarity of surface texture is extraordinary. This way of working is similar to that of the pointillists (also called neoimpressionists) such as Seurat and Signac.

According to the pointillists, colors were not to be mixed on the palette but cleanly applied one beside the other on the canvas. (The term "divisionists" stems from this.) The colors were supposed to converge and complement one another only when they met on the viewer's retina. Verdaguer, like the pointillists and impressionists, juxta-poses colors on the canvas —but he also mixes them on his palette. The greatest difference is that the pointillists claimed to work in a systematic way, but Verdaguer operates intuitively.

Figs. 86 and 87. Joaquín Mir (1873-1940), *Pastoral*, Museum of Modern Art, Barcelona. Isidro Nonell (1873-1911), *Reclined Figure*, Museum of Modern Art, Barcelona. Mir and Nonell, two famous Catalan artists, are Verdaguer's favorites —one for his color and abstract approach to composition, the other for his short brushstrokes. The influence of both these artists can be detected in Verdaguer's own unique style.

86

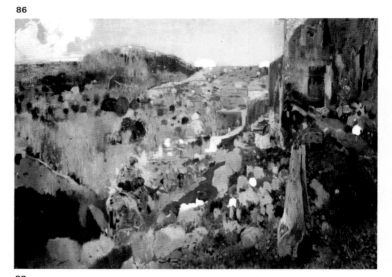

87

8

Fig. 88. Verdaguer continues working in his somewhat undefined and pointillist manner, juxtaposing brushstrokes and colors to create a harmonious ensemble of tones. He is unconcerned with forms, he concentrates instead on the value contrasts, balanced composition, and color harmony of the picture.

Fifth stage: Rhythm

"I prefer to work outdoors because —if you'll forgive the cliché— I feel freer there. Although I can work more comfortably in my studio with my sketches, the truth is that I feel more obliged to follow what I took down in the sketch. With a natural scene in front of me, I can paint whatever I want to depending on how it inspires me. Painting in the studio from rough drawings or photographs tends to be more a question of elaboration; it's more intellectual than painting outdoors. You can enrich your work more by relying on your own personal archive of visual memories."

While he speaks, Verdaguer continues to fill in the canvas with his characteristic brushstrokes, but in a calmer and more meticulous way now. The strokes are more abundant but still remain distinct and do not fully merge with one another. Note the bottom right corner, which in the last stage contained only very thin paint. Now it has been filled in with blue and green brushstrokes, some of them wide and light, and others finer and darker.

Another visible difference between this stage and the preceding one is the work Verdaguer has completed on the dark central tree. The green strokes he has added define its texture and volume more and more clearly —yet still in an impressionist style.

But all over the canvas there are new strokes. It is already a different painting. One subtle but significant difference from the point of view of composition is a change in the mountain delineating the background. (It could just as easily be referred to as the blue strip that divides the top third of the composition from the bottom two-thirds.) This blue mountain has been reduced in size and now has more of a peak. Verdaguer felt that there was too much blue next to the central dark form. He took a cloth, wiped off some of the blue to "chop off" the mountain peak, and repainted over it in yellow.

89

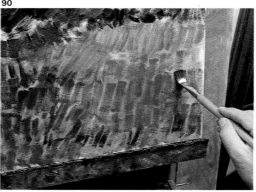

90

Figs. 89 and 90. Just Cézanne did it, painti with wide and flat brus es, Verdaguer continues fill the canvas with shad and almost abstract form using patiently elaborat colors.

"I'm interested in maintaining a certain rhythm in this painting, a horizontal rhythm counterbalanced by a few vertical shapes. And that sort of peak shape was spoiling the rhythm in the painting," explains Verdaguer.

This is plainly and undeniably so. Compare this stage (fig. 91) with the last (fig. 88 on page 35) to see how the flat, horizontal version of the blue strip notably improves the compositional balance of the painting.

Verdaguer has made something else smaller: the gap in the central tree through which we glimpse the yellow sky. This, too, contributes to the reproportioning of the painting.

Fig. 91. Ever since its second stage (see page 32), this painting has suggested a ''finished'' work in spite of its rough, sketchy look. Now, in its next-to-last stage, it is truly almost completed. It serves as a good lesson on the process to follow in order to paint a good picture.

He proceeds to fill in all the spaces in the painting, brushstroke by brushstroke, always using thick color but not overloading the brush. From time to time, he sits back in his chair to view the painting from a certain distance, proceeding to add on values and hues here and there for emphasis, watching for the effect the painting produces at each moment. Sometimes Verdaguer decides to leave his chair and goes to view the work from the far end of the studio. Occasionally he paints standing up.

He has used a lot of ultramarine blue, which is the only blue he ever uses. He goes on adding yet more of it.

Occasionally he modifies segments that do not meet with his approval, using his palette knife to scrape off the paint just applied, and then repainting over them.

The painting has acquired a thickness but it is still on the borderline between the representational and the abstract.

91

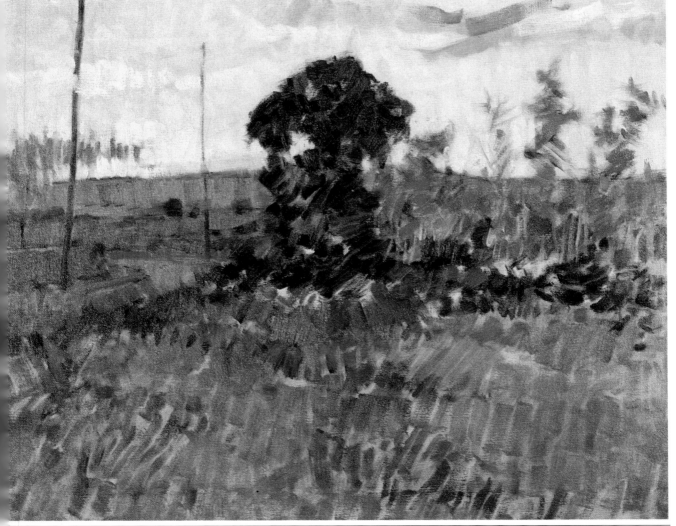

Sixth stage: Final details

Now that the problems of the overall composition have been solved, the artist is ready to add the finishing touches to his work. He begins to introduce the flowers of the central area, painting them as specks of yellow, white, and vermilion.

Note how these light, decisive touches of bright colors give life to the painting and bring into focus the many duller, more neutral tones that cover the majority of the space. All the tones have their role to play in the ensemble, but these little specks of color establish the overall harmony.

The artist cleans his brush with turpentine, dries it with a rag, and makes up a pale pink with which he touches the lower left side of the canvas. He does the same with a mauve color on the right, and then adds a few clean strokes of green, some of raw sienna in the bottom left corner, and a few touches of pearly gray.

Look back again at the sketch (fig. 77 on page 30) and try to analyze the main adjustments that the artist made in the finished painting. Here are some of them.

The central tree has a gap through which the yellow sky can be seen. This is one result of having "chopped off" the blue strip, as you remember. In the original sketch, you could see blue through the hole instead of yellow, so that it did not stand out so much. There was barely a contrast. "In the sketch," says the artist, "there was already a hint of a gap, but I wanted to make it lighter because I had the impression that the area looked too thick."

Another obvious difference is that the sky now takes up more space: It has gone from occupying a quarter of the canvas to a third. "I wanted to make it wider because I felt that in the sketch it seemed to be too overwhelmed," explains Verdaguer.

The treatment of the sky is not the same either: The vertical brushstrokes of the sketch now yield horizontal brushstrokes in blue and indigo in the upper right of the canvas.

The telephone poles stand out more too. Note how in the preceeding stage, a yellow brushstroke went over the pole on the far

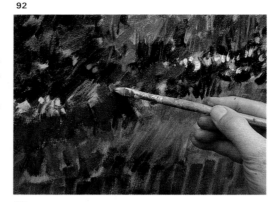

92

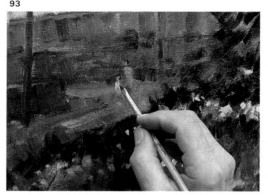

93

left, now the pole is clearly delineated against the sky. The roundness of these two vertical lines improves the compositional balance since it affords greater strength to the left side of the painting.

However, the main innovation is that Verdaguer has introduced two figures into the painting, to the left of the central tree. These two small figures, barely small blobs of paint, help us interpret the central left area of the painting, which now clearly resembles a road bordered by a fence, some trees on one side, and a pole on either side. Immediately after acting on this sudden inspiration, Verdaguer signs the painting.

94

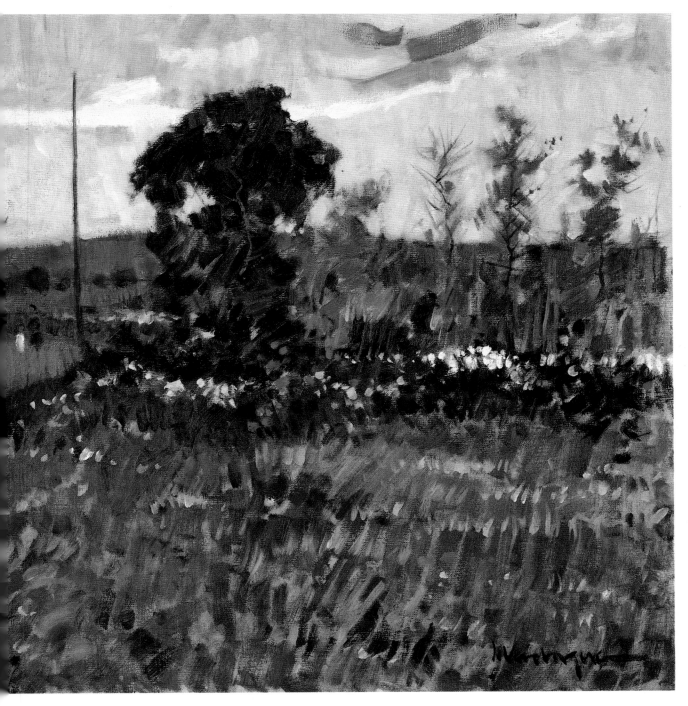

Figs. 92 to 94. Verdaguer has rectified and deepened colors, adjusted hues, heightened contrasts, and added new elements to his painting —flowers, tree trunks, figures— but still maintained an amazingly harmonious range of colors. The foreground is somewhat hazy, like an out-of-focus photograph, and the middle ground is full of suggestions of form and color. The flowers, foliage, and mountainous background all contrast with a perfectly luminous sky.

The studio

95

José María Parramón is devoted to art education. He has painted, written, and edited —all with the object of teaching how to paint. To write this section of the book, Parramón the journalist goes to his appointment with Parramón the artist, thinking that the artist himself will do a large part of the reporting for him. (You do not come across a painter who is prepared to talk about his work methods and creative process every day!)

Parramón's studio faces northeast. Because of this, he can avoid direct sunlight at any time of the year, which has advantages when seeking color harmony. He has also set up his easel so that the light comes from the left —although he does not believe this is absolutely necessary.

Parramón has another studio nearby in a mountainous area, but the one we are in now is modest in size. He feels that he does not need any more because his paintings are of normal size. He always works on an easel.

There is no lack of good sound equipment though: a turntable, a tuner, good speakers, and —just in case of power failure— a battery-operated radio cassette player. Parramón always works with classical music, from Italian baroque to German romanticism. If he paints in the country, he takes along a cassette player and a good selection of tapes.

96

97

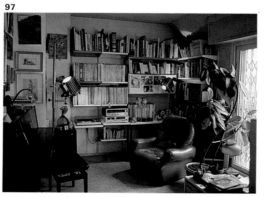

It is a clear winter morning with a hard cold sky, and Parramón prepares to paint in natural daylight. The tone of the day does not go too badly with the subject chosen: a landscape of old Castille. The work in the studio is going to be based on old sketches and studies made quite a while ago.

Fig. 95. José M. Parramón, artist, teacher and professor of fine arts, has had numerous exhibitions and won many prizes. He has supervised various art education centers and has written and published books of drawing and painting, which have been translated and published in fourteen countries.

Figs. 96 and 97. His studio measures about 29 1/2 feet × 13 feet (9 × 4 m), more than half of which is reserved for painting. The other half is for reading and listening to music.

Figs. 98 to 101. Here are some of Parramón's drawings and paintings. He draws and paints in practically all mediums, including graphite pencil, colored pencils, watercolors, and oils. On this page are a subject painted in oil with a palette knife (fig. 98), a snowy landscape in watercolor (fig. 99); an urban landscape in oil (fig. 100), and a portrait drawn in pencil (fig. 101).

98

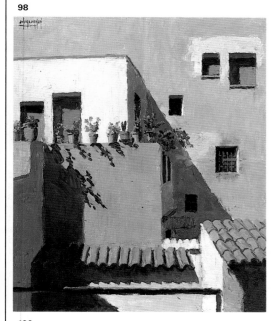

99

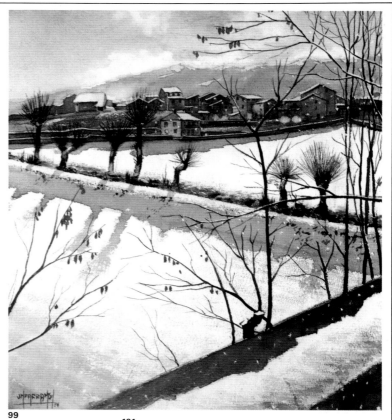

100

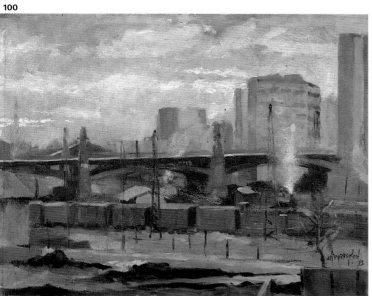

101

First stage: Previous sketch

Painting in your mind

Parramón is motionless before the white canvas, staring at it half seated on his stool. He has begun to paint in his mind. He sees on the canvas what his painting will be like; he imagines exactly what he will attempt to bring out of the subject before his eyes — in this case, his own sketches.

Let me include an anecdote here about my colleague José Sala. Sala had set up his easel in the countryside and had all his paints and brushes ready, when a group of people began to surround him, as so often happens in these situations. Seeing him standing so still before his white canvas, somebody said, "Aren't you going to start painting?" Sala calmly replied, "I'm already painting."

First stage: The drawing

Parramón is comfortable starting to paint without first producing a charcoal study. However, if you don't feel quite sure of yourself it is better to do a charcoal sketch first.

Some of the shading is already hinted at in the sketch, so that some of the volumes begin to evolve. As Corot said, "Start with shade; volume is the most important thing." Whether drawing or constructing even in a sketchy way, the important thing is to convey volume. Ingres said, "Painting is the servant of drawing," that is painting does what drawing orders it to do. Of course we should not allow the great Ingres to overshadow what the equally great Titian said before him: "You should not think that you draw before you paint. You have to think that you are painting from the beginning."

Parramón decides to paint this rural landscape with neutral colors —or rather, with a neutral range tending toward warm colors. He begins with burnt umber, cobalt blue (although ultramarine blue could also be used), Prussian blue, and yellow or yellow ochre for light areas.

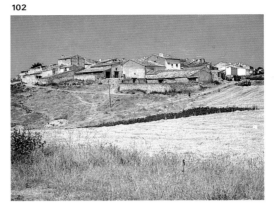

102

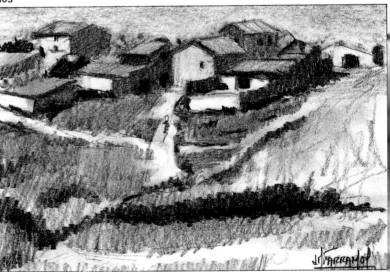

103

Figs. 102 and 103. "A few months ago," explains Parramón, "I was painting in the fields of Castille and I took some photos like this one of a small village, which will now be the subject of a landscape in oil. I already drew this sketch in penci to study the composition and got to know the subject better."

Gray is used a great deal in this early phase —different grays ranging from warm to cool, and from lighter to dark, but always dull, neutral colors.

It is time to remind ourselves that neutral or dull colors are obtained by mixing unequal amounts of complementary colors an adding a whitish color to the mixture. (Fig. 106 shows the formula for two neutral colors and their practical application.)

104

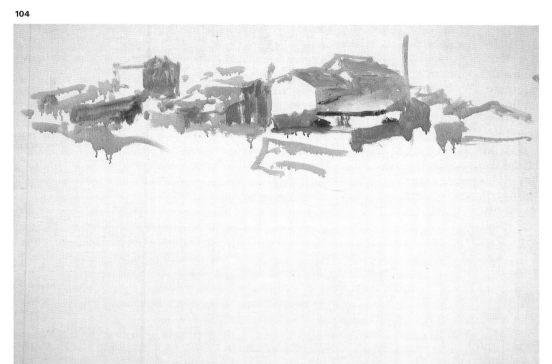

105

Figs. 104 and 105. Parramón continues, ''The pencil sketch enables me to paint directly onto the canvas more easily. And I do it with a number 6 round brush with very diluted paint. From the first brushstrokes, I try to approximate a range of neutral colors, which is ideal for this subject.

106

HOW TO MIX NEUTRAL COLORS

To mix a grayish, neutral color, combine two complementary colors in unequal proportions, and then add white. Here carmine madder and green were used.

If more carmine madder than green is used, the resulting neutral color will be warm. More green than carmine madder yields a cooler gray.

A

B

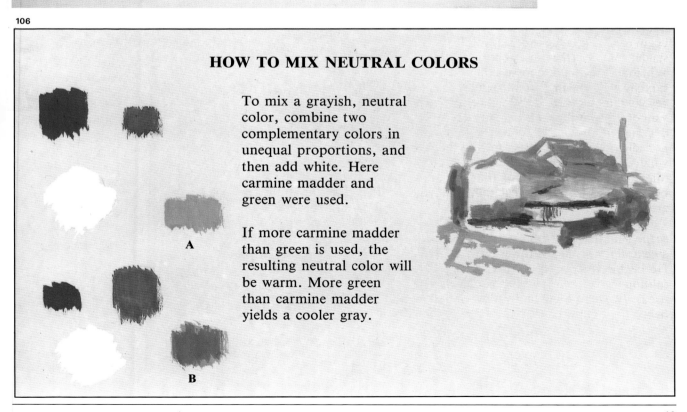

Materials for painting in oil

Colors

Let's talk about colors to begin with. There are three primary colors, as everyone knows: red, blue, and yellow. "But not just any red, blue, or yellow," points out Parramón; "Specifically, carmine madder, Prussian blue, and cadmium yellow medium are the true *primary colors*. With these and *white* it is possible to paint any subject. But most artists work with a greater assortment of colors —about ten or twelve, not more."

And he mentions the popular colors used by the professional as he distributes them around his palette. Starting with white on the right and going counter clockwise in this order, the other colors are:

1 Titanium white	6 Carmine
2 Lemon yellow	madder
3 Yellow ochre	7 Emerald green
4 Burnt umber	8 Cobalt blue
5 Vermilion light	9 Ultramarine blue
10 Prussian blue	

"You can add *ivory black* to these colors," says Parramón, "although I prefer to mix it. To obtain a cool black, I mix *Prussian blue* with *burnt umber*. For a warm black, I use *burnt umber, carmine madder*, and *emerald green*."

So that he can experiment and study, Parramón uses many brands of artist-quality oil paints —for example, Winsor & Newton, Talens, Grumbacher, Schmincke, Lefranc & Bourgeois, and Titan. Sometimes he also paints with student brands, like Van Gogh, Amsterdam, or Études de Lefranc. He finds these brands cheaper but just as good.

Supports

Parramón paints on quality canvas and frames. "It's a mistake to paint on poor-quality material," he warns. "The material should be linen or cotton, densely woven and well primed (a layer of gesso). Sketches and small paintings can be done in oil on a prepared wooden board, or even on thick drawing paper that is well sized."

Fig. 107. This is Parramón's basic palette nine colors and white. By adding lemon yellow, burnt sienna, permanent green, and ivory black, he will reach a total of thirteen colors and white. This assortment is commonly used among professional artists.

Fig. 108. The most frequently used support for oil painting is linen or cotton canvas. You can also paint on an ordinary board or on good-quality thick drawing paper, which is a good size for sketches and studies.

Fig. 109. Sable brushes are normally used for oil painting, although thin marten brushes can also be used for preliminary outlining and small details. Brushes come in three designs or shapes: flat, filbert (also called cat's tongue because of its shape), and round. You can also paint with a palette knife —or just use it for scraping paint off the canvas if you want to change something, and for cleaning the palette. The most practical palette knives are shaped like a mason's trowel.

107

108

Brushes and palette knives

Parramón works with eight or ten sable brushes, ranging from number 8 to number 24. He generally prefers flat brushes. For painting small details, fine lines, and so on, he uses a number 6 or number 8 marten brush, but warns, "I don't think it's a good idea to get used to painting with thin brushes because they lead to an affected, over fussy style."

This time Parramón will not be using the palette knife for painting, but only for cleaning, correcting, and removing paint from the canvas if necessary. For whatever purpose, he prefers a palette knife shaped like a mason's trowel.

Palettes, solvents, rags, and paper

There are plastic palettes and even paper ones, but Parramón prefers them in wood, either oval or rectangular. Many artists use any wooden surface (like a table top) for a palette.

Linseed oil and turpentine are the traditional solvents for oil paint.

Some manufacturers sell a ready-made mixture of turpentine and linseed oil, but you can make it up yourself by mixing equal parts of both products.

Many artists, including Parramón, use only one solvent —turpentine— which gives a matte finish.

Finally, Parramón uses rags and strips of newspaper to clean his brushes. For this he uses undiluted turpentine, which is cheaper than a mixture with linseed oil.

Fig. 110. Palettes for oil painting can be made of wood, plastic, or paper. Paper palettes are relatively new and are made from sheets of absorbent paper compressed into a palette-shaped block. You peel off a layer of paper each time you use it. It is also handy to have something to help you carry canvases on wooden frames (see A below). Other accessories are charcoal for preliminary studies, fixative for the charcoal, linseed oil and refined turpentine, and rags and newspaper for cleaning your brushes and palette.

109

A 110

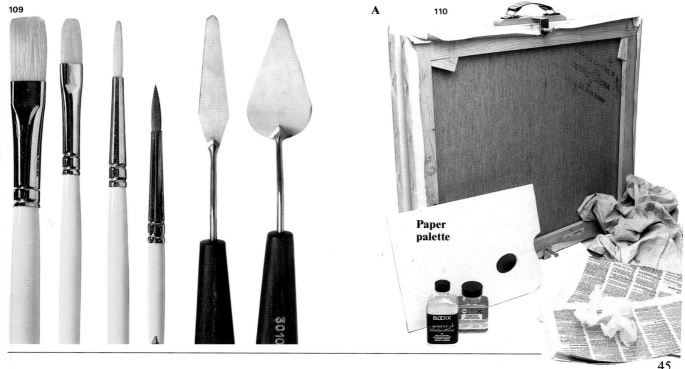

Paper palette

Second stage: Painting the sky and laying out space

111

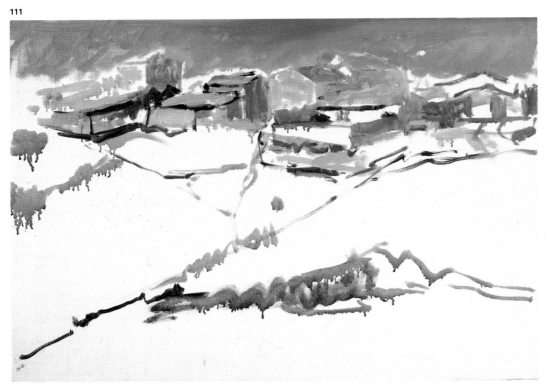

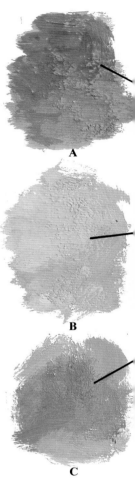

A

B

C

Parramón now decides to paint the sky, not strictly in blue but in a gray tone tending toward blue.

He must immediately work out the color of the sky since he will then evaluate all the colors in the lower section of the painting, against that sky. Without it, he would not have the necessary contrast available in order to judge, contrast, balance, counterbalance —in sum, to harmonize the relationships among the various colors that will constitute the finished work.

Now, having allowed himself the pleasure of painting (filling a large blank space with color is what most gives you the sensation of painting), Parramón goes back to the drawing. With the paintbrush loaded with burnt umber —very diluted with turpentine and lightened with white— he begins to establish the basic relationships of the fields and hills in the lower area.

Here it is not a question of drawing actual shapes, but instead of determining proportions and marking the boundaries of space. There are no specific forms yet, just a general layout of the paths, grass, and earth.

The painter lightens his colors so that a moderately warm range is suggested, which will be dominant in this painting: neutrals mixed from lemon yellow, raw sienna, burnt umber, and yellow ochre.

Once the color is mixed, Parramón dabs a brushstroke of it onto the white of the canvas (''they all do that,'' he says) and then is able to see the color more accurately. Then he goes back to the palette and modifies it. He touches the houses and the countryside with the same hues.

Fig. 111. In this second stage, Parramón uses very diluted paint to determine the basic lines dividing the field. At the same time, he fills in the sky and houses in general.

Third stage: Filling in spaces

112

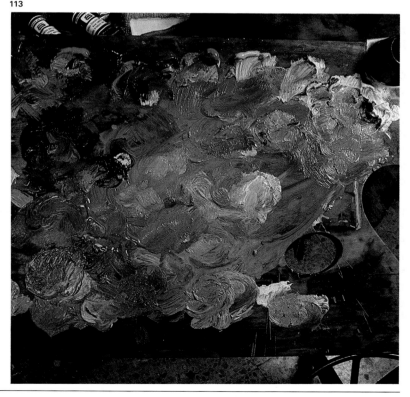

Figs. 112 and 113. Parramón covers the whole canvas with patches of color without overly concerning himself with the drawing or forms established earlier. ''I think it's more important at this stage,'' says Parramón, ''to eliminate the whiteness of the canvas to avoid false contrasts, so that you can better adjust the hue of each color.'' Note how the samples of color (A, B, and C) contain several hues but give a more neutral appearance when seen from a greater distance. Also note (fig. 113) the complete range of neutral colors with which he is painting this landscape.

113

The time has come to fill in extensive areas with color, taking into account the divisions made in the previous stage. But note that this does not mean mixing a large quantity of one color and using it to fill in an entire area, but instead, blending that color with other colors.

The color of each space is a discovery, but it is not suddenly produced. Brushstrokes are mixed until the painter says, "This is the color I'm seeking." He believes that working outdoors in front of a real landscape makes it easier to find the right color. It becomes more difficult in the studio when an artist is working from sketches. Perhaps this is because the actual subject is like a muse for the painter, it inspires him more than any reproduction of it ever could. And we do not mean just superrealistic, photographic painters, but also painters who take quite a lot of liberty in their figurative interpretation.

Gradually, the whiteness of the canvas disappears, and what emerges is the actual relationship among the colors, the balance of all the hues.

Fourth stage: The houses

Fig. 114. In this fourth stage, Parramón reaffirms the drawing and the composition in general, starting with the village houses. He draws and paints them at the same time.

114

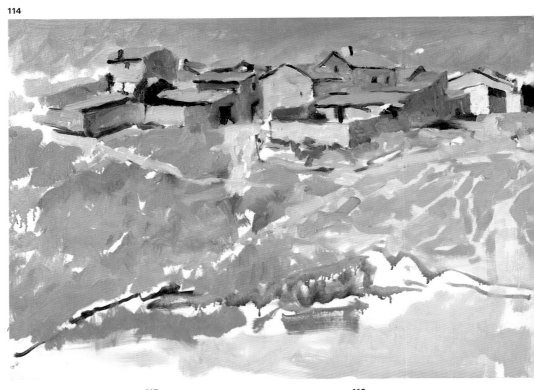

Now we must go back to the drawing —to the houses— which will in some way capture the visual interest of the painting and put the rest into proportion.

Since they are houses they must be built. The painter constructs them almost the way the architect and mason did in their day. But Parramón warns, "You shouldn't overdo the construction, don't make it too even."

For instance, Parramón now paints a door. With black he fills in a greater area than he needs, and then uses a brush loaded with the gray of the wall to reduce the door to its final size: He draws it by painting it. (See figs. 115 to 117.)

This method of working alla prima has its dangers. One of them is that all the colors may become too mixed, too sullied. The artist sometimes has to go over what has already been painted, introducing clean, sharp color and marking out each color's boundaries, to prevent the painting from becoming a whole mess of neutrals.

115

116

117

Figs. 115 to 117. In this sequence of pictures, we see an example of simultaneously drawing and painting the door of a house. In fig. 115, the door is disproportionately wide. In fig. 116, it is reduced on the right and on the top; in fig. 117, it is reduced on the left to its true size and shape.

Fifth stage: The overall effect

118

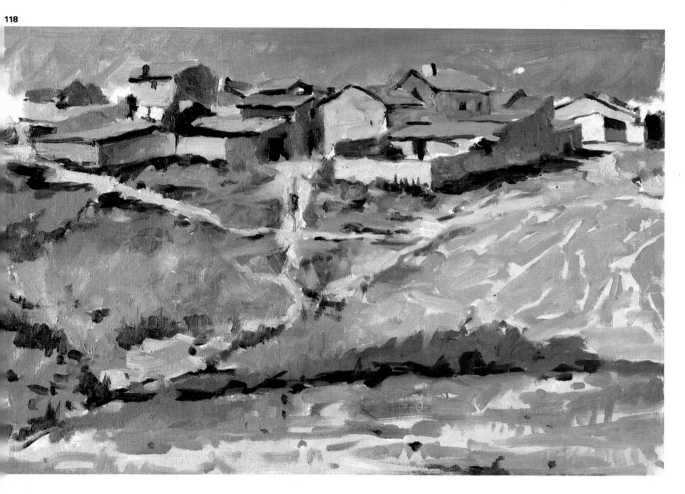

We have said there was a danger in over-constructing, but the opposite danger is allowing excessive disorder. And that danger increases when it is not a case of constructing geometrical forms but of filling in spaces without a single straight line. The Japanese, who have painted marvelous landscapes, say that nature does not have straight lines.

Parramón feels that when he began this painting, he focused too much on one area: Now he wants to do everything at once, to see the painting as a whole, to work now here and now there, always relating each of the elements to the rest, never losing sight of the fact that he is dealing with a whole. The painting is an entity.

The artist stops from time to time to clean his brushes, or even to clean the palette, so as to make the colors as pure as necessary.

These pauses allow him to see the painting with a little more distance —to see it as a whole. In this case he perceives that the general contrast and the space, forms, and colors are well established.

Fig. 118. The adjustment of color and the more precise drawing of the forms continues to progress in this fifth stage, in which Parramón has worked mainly on the hues and forms of the land. Fortunately oil paint is opaque and spreads well, so it is possible to make changes and improvements by superimposing layers.

Sixth and final stage: The sum and the parts

119

"But you shouldn't get too bogged down in detail," says Parramón, steering the painting toward its completion. He measures the distances of the painting, gets up, and views the almost completed work from a couple of yards away.

He begins to paint again, now standing up. From his new position he sees the picture in a different way. He has established new contact with it.

Looking at this new stage and the previous one on page 49, it is easy to see that he has changed as much in this next-to-last stage as in all the previous ones. He has repainted the sky, reconstructed the houses, and readjusted the form and color of the field in front of the village. The only thing that has been saved in this general revision is the foreground, the area in front of the green bushes. By defining the houses more clearly and by making the foreground less concrete, as if it were out of focus in photographic terms, he has emphasized the depth of the painting.

When an experienced painter is developing a painting, a certain instinct allows him to find the necessary hues and colors almost spontaneously. The artist has internalized the range that will constitute the color harmony of his painting.

The moment when a painting is nearly done is perhaps when an artist experiences the greatest physical pleasure in painting, or rather the pleasure of seeing something he imagined spring to life on the canvas. But it is pure pleasure just to paint.

The almost-complete stage is also a time to relax and improve the details: to enhance the lay of the land with vertical green brushstrokes, as if planting the grass; and to heighten some warm shadows with carmine madder, making the pearl gray paths cleaner and sharper, and to lighten the form of the group of buildings on the right by creating a dark shadow on the ground. The whole group of buildings now has greater strength.

Parramón puts some gray brushstrokes behind the mass of green, elaborates on the pearl gray of the paths and touches them up, and darkens the central vertical path with a dark shadow. Soon the artist stops, paintbrush suspended in midair, an inch away from the canvas. He steps back, looks at the painting, and appears satisfied.

"I'll leave it. It's finished. I don't want to get bogged down in unnecessary details," concludes Parramón.

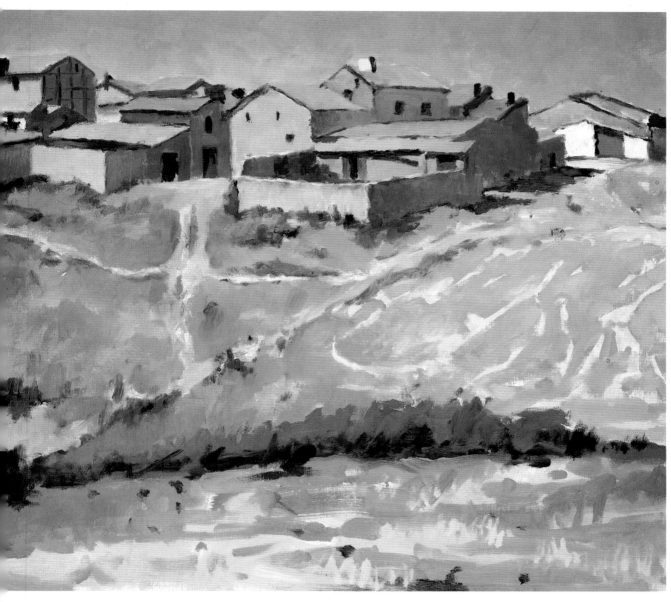

g. 119. The subject was landscape of a village in ˙d Castille, an arid place ˙here the sun paints the ˙uses and fields yellow ˙nd brown and gray. ''To ˙aint a landscape like this ˙ne, I thought of a sche- matic composition and a color harmony that would express the characteristics of the subject. I chose an unusual frame with the sky and strip of houses in the upper part of the painting so that they occupy less than a third of the space and leave the rest of it for the field; this expresses the idea of a dry land, and arid earth. I also felt that a scene like this required a palette of undefined col- ors, neutral and without much variation, in the range of ochres and dull siennas.

''That was the idea. This is the painting, completed and signed.''

Materials and colors

Joan Condins, a well-known landscape painter with dozens of successful exhibitions behind him and work in various museums, was born in 1929. "I'm a Leo," he tells me. He started a basic course at a fine arts school when he was twelve but was forced to leave when he was eighteen. However, he continued to study art on his own, "without teachers or professors" as he himself admits.

The results show: Joan Condins is now a respected painter whose style and work methods will interest many art enthusiasts, both amateur and professional.

Condins nearly always works with square canvases. He always uses number 8, 10, 12, and 14 sable brushes and prefers to paint in vertical brushstrokes, as we will soon see. There are no dull earth colors, nor is there any ochre or sienna on his palette.

This is Condins's palette:	
Titanium white	Permanent green
Cadmium yellow	Emerald green
medium	Ultramarine blue
Cadmium orange	Ultramarine deep
Cadmium red	Cobalt violet
Vermilion	

"Note how little I use the palette knife," explains Condins. And he goes on to talk about color: "I see landscape as a color symphony. I think earth colors take away luminosity; they sully a painting. I consider violet, on the other hand, essential for enriching the color of shadows."

"I see that you don't use black," I tell him.

"It's not necessary, and always presents the danger of dirtying the painting. As you know, you can make black by mixing emerald green, carmine madder, and ultramarine deep."

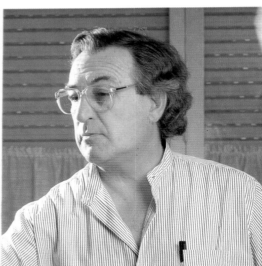

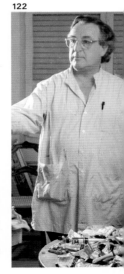
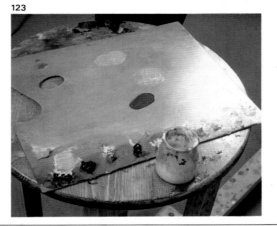

Figs. 120 to 123. These pictures show Joan Condins painting a landscape in oil. The process will be illustrated in detail on the following pages. In figure 121, we can see his easel and gray-primed canvas between two stools that he uses as tables to hold his supplies and palette colors.

The artist's working method

One notable aspect of Condins's method is that he paints his landscapes from the natural subject but nearly always finishes them in his studio. Often he makes one or more watercolor sketches on location, on which he then bases an oil painting in his studio.

"I use this method especially in summer," interrupts Condins, "because I can't stand the heat. That's why I usually make a few quick sketches in watercolor and then paint the pictures in my studio." This is the process we will follow for the landscape he is going to paint for us, a scene from the Pyrenees with an amazing mountain range in the background, a small rustic village nestling in the foothills, and contrasting fields of wheat and other vegetation in the foreground.

In the figures below you can see the watercolor sketches and an earlier oil painting Condins painted of this subject. He will now paint a new version.

124

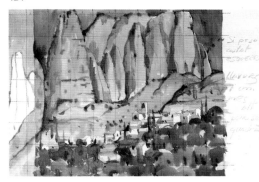

126

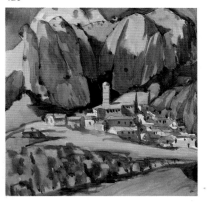

125

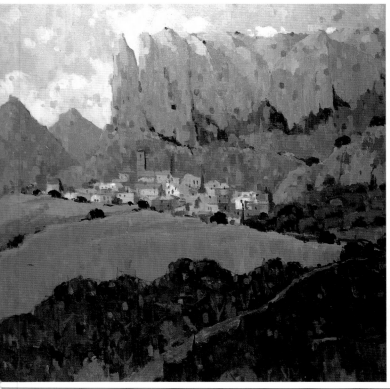

Figs. 124 to 126. Joan Condins produced the oil painting shown in figure 125 in his studio, basing it on watercolor sketches done outdoors from the natural subject. The oil painting measures 43 inches × 43 inches (110 cm × 110 cm). He will now paint a new version, still square but smaller —23 1/2 inches × 23 1/2 inches (60 cm × 60 cm)— by referring back to these earlier paintings and by relying on his good visual memory.

Condins's work: A very personal style

127

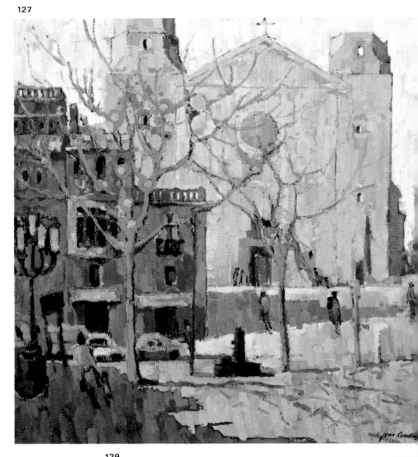

Here are some examples of Condins's work. Apart from the decorative content, several factors are worth mentioning. In the first place, he has a clear preference for square canvases, as illustrated on this page the two paintings on the facing page are exceptions.

Another point worth mentioning is Condins's mastery of watercolor as well as oils, so that many of his sketches can be reworked into finished paintings. The seascape shown in figure 128 is an example of this.

Finally, note how in all his paintings, the form and color are worked with vertical brushstrokes —even in areas like the sky, the ground, and the water.

128

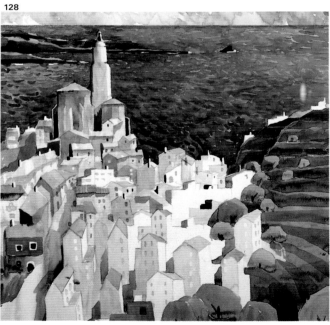

129

130

Figs. 127 to 131. These five paintings by Joan Condins show his style and quality as a professional artist. Condins nearly always paints on square formats; the two paintings on this page are exceptions.

131

First stage: Drawing with acrylic on gray canvas

132

133

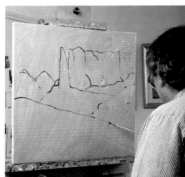

134

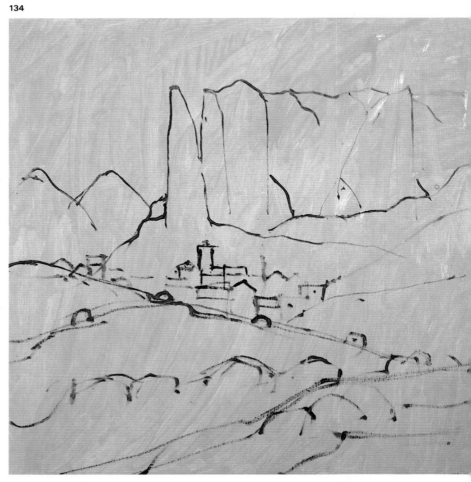

Here is the canvas, a square one measuring 23 1/2 inches × 23 1/2 inches (60 cm × 60 cm), prepared with a layer of gray paint (fig. 134).

Condins works with the watercolor sketch next to him but his earlier oil painting further away. "I finished this painting only a few days ago," explains Condins, pointing to it, "and the truth is that I could repeat the version I'm now painting by referring only to this watercolor."

Condins now opens a tube of ultramarine blue acrylic paint, squeezes some onto his palette, and comments: "I like to paint nature from my studio." But he quickly adds, "Of course, that's if I have previous knowledge of the subject, as in this case. I like it because I can paint with greater freedom here; I improvise and interpret better."

And he begins to draw the subject with the ease and confidence of the master, using a number 4 sable brush and ultramarine blue. He proceeds from top to bottom and from left to right like one who is completely familiar with the subject and knows its proportions by heart.

Figs. 132 to 134. Condins begins the picture by doing a linear drawing over the gray of the canvas. Condins always uses flat brushes, and he paints in his own style with vertical brushstrokes.

Second stage: The first layers of color

135

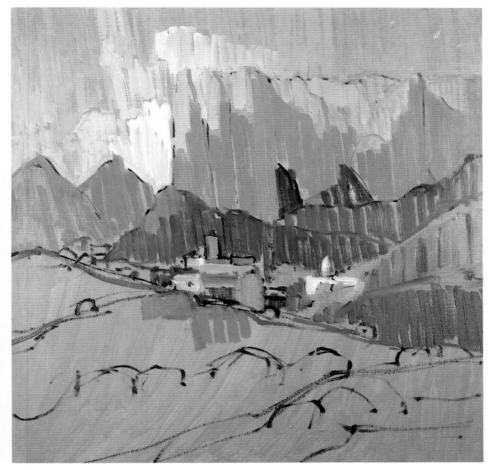

Fig. 135. Joan Condins always paints over canvases he first primes with a medium gray. He feels that this method allows him to get closer to the correct color and achieve greater contrast and brightness.

Outline by outline, brushstroke by brushstroke, Condins paints first the sky and then the background mountains in carmine madder, violet, ultramarine blue, and white. Next he paints the foothills just behind the village.

As he moves on to the houses and church tower, he explains about the gray background. "Have you noticed how, by painting over gray, I'm working on a neutral background that allows me to get closer to the appropriate color, while also making the lighter colors appear brighter for better contrast? See these sketches of the village houses, for example."

I now comment: "As you know, Rubens painted everything over gray. But Titian and Velázquez painted over a color similar to English red."

Condins nods in agreement. "Well, I prefer a gray background, although sometimes, when I haven't prepared the canvas, I improvise and paint on white. But I do prefer gray."

Third stage: Filling the canvas

Yellow, orange, a little blue, and white, and here we already have the ochres for painting the houses and fields in front of the village. Still, Condins uses the same vertical symmetrical brushstrokes, one beside the other.

"Why these small gaps between the strokes," I ask him, "and why the same vertical brushstroke?"

"It's a habit, a tendency, and a style. I feel good using vertical strokes. I like outlining over and over and juxtaposing more outlines and more colors: it's crucial to my way of painting. It's a style, really —my style."

He now mixes emerald green and a little violet to obtain a deep green, of which he applies one or two quick dabs to the can-

vas. Then he stops and checks, speculates, and goes back to the palette to add ultramarine blue and a little carmine madder. He begins to paint once again, closer to the previous strokes. The color is now deeper, almost black —a greenish black with blue overtones. Apparently it is just right, since Condins continues to use this color with slight variations for much of the first layer of the foreground. He explains, "This is what we all do to test a color: dab a few strokes over the actual canvas to test it, and then proceed or adjust it, depending on the result."

"Of course, painting on the canvas over or beside other already defined tones is not the same as making up a color on the palette beside other mixtures of colors."

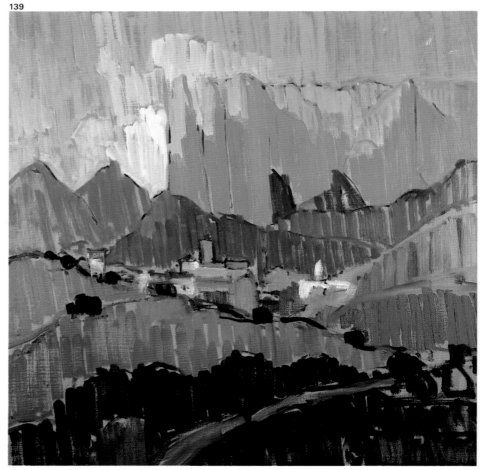

Figs. 136 and 137. These two figures illustrate an important lesson: the fact that professional oil painters out try colors directly on the canvas with one or two brushstrokes. Once they can see the color in context, they either use it or adjust it.

Figs. 138 and 139. By the end of the third stage, the canvas is covered with its first layer, worked stroke by stroke and always in a vertical direction.

Fourth stage: Adjusting form and color

140

141

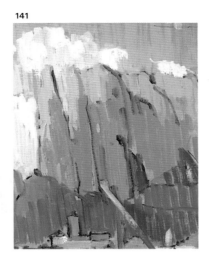

If you compare this stage with the previous one (shown in fig. 139), you will see that the basic forms and colors are the same but that Condins has made the volumes and outlines more explicit. He has also perfected the forms and colors by painting in light, shade, and reflections, especially in the upper half of the painting. Also note how Condins has juxtaposed complementary colors for vivid contrast in several areas: The sky and mountains both contain yellow-oranges and blue-violets right next to each other.

142

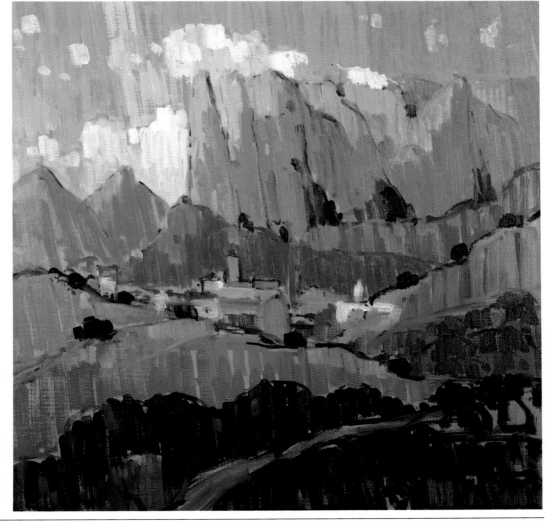

Figs. 140 to 142. All three pictures on this page illustrate Joan Condins's work in adjusting forms and colors and in creating contrast. He juxtaposes complementary colors like blue-violet and yellow-orange in the light areas and shadows of the background mountains.

Fifth stage: The poetry and prose of art

The palette shown in figure 143 best explains the range of colors that Condins uses to obtain the results seen in this fifth stage of the painting. It is a luminous, bright palette of pale blues, bluish grays, oranges, and pinks—the palette of a colorist. The three pictures at the bottom of this page and the reproduction of the painting on the facing page represent an exclusive lesson in color by the artist.

Condins is a poet of color —but he is simultaneously an expert craftsman who makes rational, deliberate choices. "Tell the readers," he comments between brushstrokes, "that art is poetry but also prose. There are times when one feels inspired and really experiences the sensation of creating something, still, one should not forget that art is also job, and at those times of mounting inspiration one must come back down to earth to put on more color, to clean the brushes and palette."

Certainly, the mechanical aspect is important. Condins always paints with a piece of terry cloth in his left hand to clean the brushes with from time to time after he dips them into the turpentine. And when the palette knife gets overloaded and dirty, he cleans it with an old rag.

143

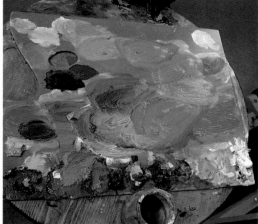

Fig. 143. This is the bright, luminous palette of Condins, the colorist, moments before he cleans it to put on more colors and work with new mixtures.

Fig. 144. Condins cleans the brushes as he paints, cleansing them in turpentine and drying them with a terry cloth rag.

Figs. 145 and 146. To clean the palette, Condins uses a palette knife to scrape off most of the paint, and a cloth to wipe the palette clean.

144

145

146

147

148

149

150

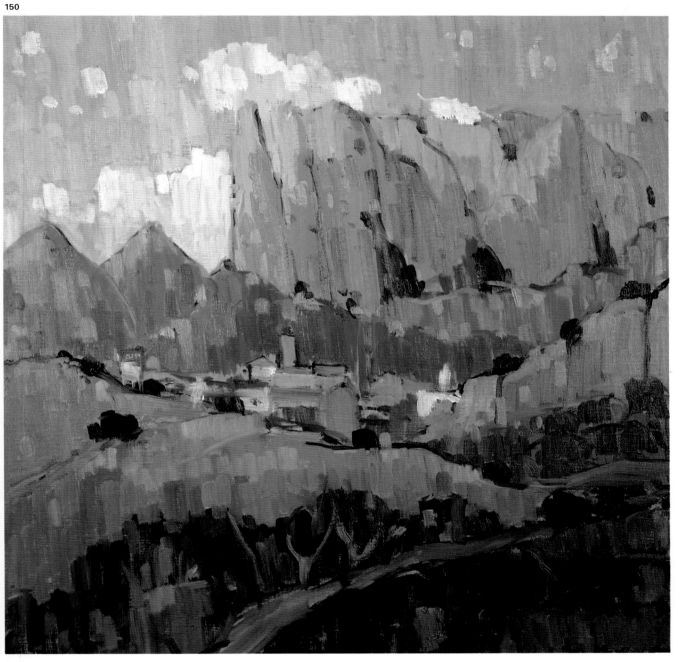

Figs. 147 to 150. These pictures illustrate how Condins arrives at the next-to-last stage of the painting. One brushstroke at a time, he applies one color over another. Note also how he holds the brush near the tip of the handle and cups it in his hand. This makes his vertical brushstrokes easier and lets him distance himself from the canvas, so that he can better see the painting's progress as a whole.

Sixth and final stage: A symphony of colors

Fig. 151. The last touches of color made by Condins in his landscape in oils: a vibrant play of blue, violet, red, and carmine madder colors whose harmony and contrasts enhance the foreground of the painting.

Figs. 152 to 154. In figure 152 you can see again the first version of the landscape. Compare it with the picture on the facing page, which shows the version Condins has just finished painting. The subject is the same but the paintings are different. In the second one the color is far brighter and more dynamic, with a less calculated and faster execution. The overall look is fresher and more spontaneous, although the painting is perfectly constructed and wonderfully harmonized.

Both versions are excellent paintings by our guest artist, Joan Condins.

151

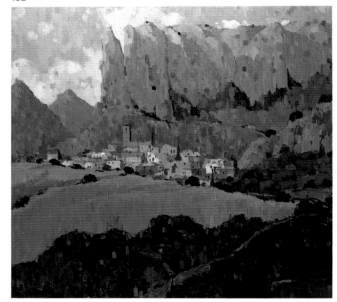
152

153

The final stage of the painting involves careful thought intermingled with brief strokes of color. Condins evaluates, clarifies a detail, enhances a contrast. He adds windows to the village, red and blue traces to the foreground, white highlights to the clouds on the left, and numerous rapid touches here and there of blues, pinks, yellows and ochres.

Condins now places his earlier oil painting (fig. 152) beside this new version.

He examines both canvases closely —comparing, reflecting, and judging the results for himself.

"This one," he says, pointing to the new version, "is brighter in color, less calculated, more spontaneous. Well, of course it did come out of greater improvisation and was worked in less time. When you paint in the studio from rough drawings or sketches made outdoors, as I have just done now, you run the risk of ending up with something cold and less expressive. But experience has taught me that working in the studio is, first of all, more comfortable. Outside you can feel hot or cold, and nobody can paint when it's very windy. Also in the studio there are no changes in light, which affect color and contrast. And finally, painting in the studio forces you to invent, to create and paint what *you* want, as Monet said, and not what the subject wants."

The lesson has ended. Condins puts his signature on the bottom right corner. The symphony of color is complete.

154

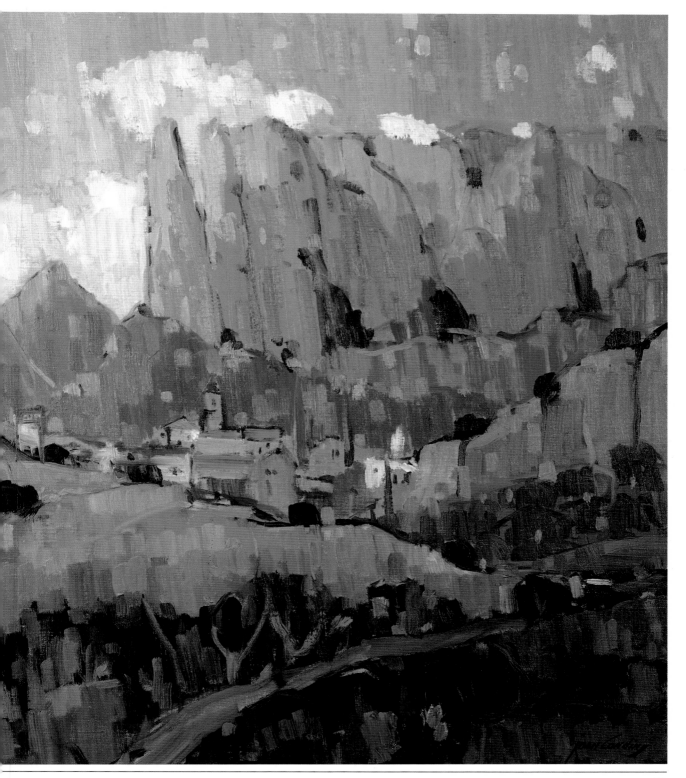

Contents